Worlds A-part

Paintings by
The Singh Twins

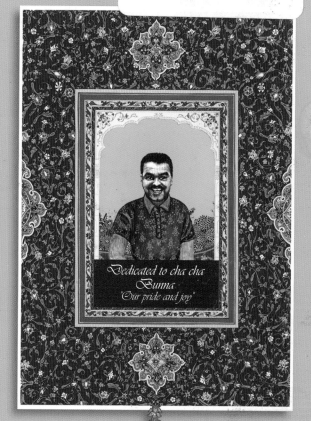

Dedicated to cha cha
Bunna
"Our pride and joy"

Essays by Dr Geoff Quilley and Dr Veronica Sekules

In the artists' words............

Worlds A-part brings together some of the major commissioned projects and series of paintings we have created since the first book on our art, *Twin Perspectives*, was published in 1999. The selection of images profiled then largely explored cultural attitudes, perceptions, prejudice and identity through themes which predominantly drew on our personal experience as female British Asians, artists and twins. The current publication, however, presents a wider vision of popular culture, society, media and politics through a reinterpretation of specific historical paintings in public and private collections which encompass both western and non western traditional art forms. The hyphenated title of this book creates an ambiguity of meaning which implies both separateness (being apart from) and integration (being a part of). As such, it reflects the western social, political and contemporary art Establishments' tendency to separate the worlds of east and west and modernity and tradition in their defining and evaluation of 'Art' and cultures, where 'west' and 'modernity' are perceived as superior. At the same time it represents our defiance of this stance through the development of an art style and practice which demonstrates the relevance of tradition and non European values to western modernity, thereby questioning assumed ideals within society and culture. Hence the style and themes of many of the works profiled here highlight aspects of intercultural exchange and shared heritage and explore the interrelationship between popular culture and history. At the same time, the title can be taken to legitimize the notion of a 'separateness' which acknowledges the equality of diverse artistic and cultural expression and asserts the right of 'difference' to exist in a world where western globalisation, media and popular culture are rapidly undermining traditional values and cultural life styles.

It is impossible to express in this limited space, the complexity of issues which the title implies are explored through our art, but we feel that Dr Geoff Quilley and Dr Veronica Sekules have most effectively translated our colours and line into text and word, for which we are most grateful.

ISBN 0-9535111-1-1
ISBN 0-9543211-5-4

Contents

Acknowledgements	Inside front cover
In the artists' words...	2
Foreword	3

Introductory Essays

Past The Post: Modernism And Postmodernism in the Art of The Singh Twins. *Dr Geoff Quilley*	4-9
The Intersection of Power and Meaning: Art and Politics in the Art of The Art of The Singh Twins. *Dr Veronica Sekules*	10-15

Contributors' Biographies

Dr Geoff Quilley	9
Dr Veronica Sekules	15

The Paintings

The Iqbalnama Series	17-25
The Hart and Blake Projects	27-31
Facets of Femininity Series	33-41
The Art of Living Series	43-57
Sportlight Series	59-79

List of plates	80
Copyright credits	Inside back cover
Artists' Biography	Back cover

Foreword

Amrit and Rabindra KD Singh are a unique presence within UK contemporary art practice. Their exquisitely crafted paintings draw significantly on the traditions of Indian miniatures as well as global aesthetics and delicately undermine cultural expectations about contemporary art. The City Gallery, Leicester is proud to support a publication profiling the paintings of two artists whose beautifully wrought work has sought to make connections between cultures and to express the significance of aesthetic traditions across cultural boundaries. The City Gallery aims to support innovative cross-cultural creative activity through its programming and publications. Its support for this publication coincides with the City Gallery exhibition: Past-Modern (4 June – 9 July 2005).

Kathy Fawcett, Exhibitions Officer
Mark Prest, Acting Gallery Manager

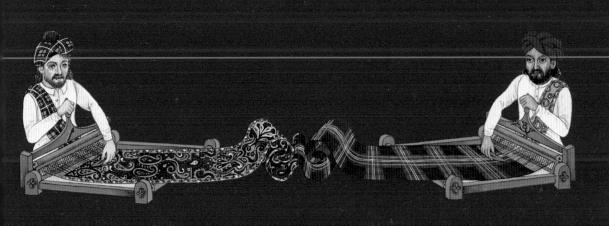

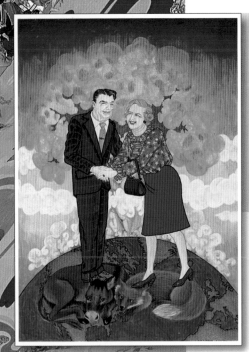

Past the Post: Modernism and Post-modernism In the Art of The Singh Twins

Dr Geoff Quilley

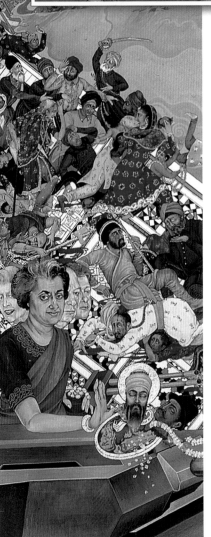

'Past-Modern', the punning term coined by The Singh Twins to describe their work, constitutes a deliberate ploy on the part of the artists to make a two-fold challenge: to the accepted orthodoxies of Modernism on the one hand, and the widespread perceived hollowness at the centre of Post-modernism on the other. The near oxymoron points immediately to the contested relation of past to present which is pivotal in differing ways to both: for Modernism, this may be said to be a relation based in denial, comprising a severing of the present from the supposed dead weight of the past, and an eschewing of tradition in the name of progressive avant-gardism; Post-modern culture, by contrast, is marked by a tendency to offer a re-appropriated, packaged, commodified past for consumption by the present, whereby history and the past are able to be reduced to consumable items within the totalizing system of global capitalism. The Singh Twins' art proclaims both these positions to be fundamentally and dangerously flawed, while offering an alternative to the isolationism of the one and the vacuity of the other. What is remarkable is not just that they do this so eloquently, but they do it as a practice-based critical discourse on art and its history in the western tradition, by asserting the crucial historical influence upon western art and culture of the culture of the non-western world. It is perhaps this dimension of their work as critical intervention that, more than anything else, gives The Singh Twins their special and significant place in contemporary British art.

The oppositional sense of 'Past-Modern' suggests also the series of dialectical oppositions around which the history of western art and aesthetics is structured. 'Past' contrasted with 'modern' recalls the opposition of 'ancient' to 'modern' that was at the heart of post-Renaissance art and its theorization. It further alerts us to the fact that the validation and legitimation of western art and its theoretical principles have, at least since the foundation of academies of art, been conceived in terms of such oppositions. As so much recent scholarship has demonstrated, dominant among these has been the issue of gender: from the exclusion of women from Academy life classes (and therefore from participation in the highest class of painting, that of history painting), to the epitomization of Modernist self-sufficiency and creative genius in the tormented macho-ness of a Jackson Pollock or the virile command of a Picasso, the post-Enlightenment western artistic tradition has been dominated by masculine values, defined by virtue of their difference from feminine counterparts. This in turn has tended to correspond to a cultural opposition between a public (masculine) sphere and a private (feminine, domestic) sphere. In addition, since the Romantic era in particular, western art has had at its core a principle of individualism, around and out of which Modernism formulated itself dialectically as a species of emancipatory struggle: the struggle of the individual against society, of the avant-garde against tradition, of originality or novelty against convention, of idealism against materialism, and of purity and freedom of formal expression against ambiguity, hybridity and compromise. The Post-modern rejection of the 'grand narratives' of Modernism is now long familiar, and does not require further rehearsal here. Yet, as an art produced by women, in a style and technique that constitute a conscious revival of a past art form that was itself produced collectively in the workshop, representing subjects that are a fusion of the worlds of east and west, in a medium that self-consciously celebrates its traditional roots, and created not only jointly but by identical twins in such a way as to disrupt totally the very notion of creative individualism, the art of The Singh Twins may be regarded as the very antithesis of Modernism, and as a deliberate effort to move beyond its constrictions. Certainly, their art is also one produced out

of struggle, but in a reverse sense: the struggle to have their work and its open celebration of tradition taken seriously by an art education system and establishment that 'advocates freedom of choice and self-expression as the "be all and end all" of contemporary art and free society but denies the validity of anything that doesn't fit into its selective, western perspective'.

If we understand Post-modernism not as an era but as a 'condition', or as the "immanent critique" of Modernism, the Twins' art may be seen as quintessentially Post-modern. In a now famous essay Fredric Jameson identified the chief tendencies of Post-modern culture as the collapsing of history or the 'fragmentation of time into a series of perpetual presents', the recourse to pastiche and quotation of earlier art, and, in semiotic terms, the breakdown of the relation between signifier and signified, resulting in a near-obsessive interest in the materiality, rather than the meaning, of language. Similarly, Craig Owens isolated the characteristics of Post-modernism in art as, among others, appropriation … accumulation, discursivity, hybridization - these diverse strategies characterize much of the art of the present and distinguish it from its modernist predecessors'. The Twins' art can be seen to share many or all of these features in some degree: their adoption of Indian miniature techniques could be treated as a form of pastiche and a collapsing of a past art form onto the present; their art is postulated upon hybridity, indeed celebrates such cultural cross-fertilization; it champions regional, communal and ethnic identities; and in its highly sophisticated use of multi-perspectival, multi-narrative compositions, it is surely an art that is highly discursive and self-reflexive. Yet, their artistic language is far from being one of empty signifiers; this is no merely ironic, rhetorical gesture, advertising its own sophisticated eclecticism. Rather, as Julian Spalding has observed, their work is 'strong because it is an act of faith'. We could say also that it is an art of commitment: social, political and religious. And, if only in this respect of commitment, the Twins' art assumes an unequivocally Modernist stance. This is most clearly seen in overt political statements of an emblematic kind, such as *Reagan and Thatcher* (page 4 inset), which not only is directly based on the Mughal miniature *Jahangir Embracing Shah Abbas of Persia*, but also refers to a western (and particularly British) tradition of emblematic political satire going back to Gillray and beyond, and more specifically, to the popular 1980s Campaign for Nuclear Disarmament poster *Gone with the Wind*. In *Diana: the Improved Version* (right) the simplicity of signification associated with the emblem is rendered still more ambiguous and complex. Not only is

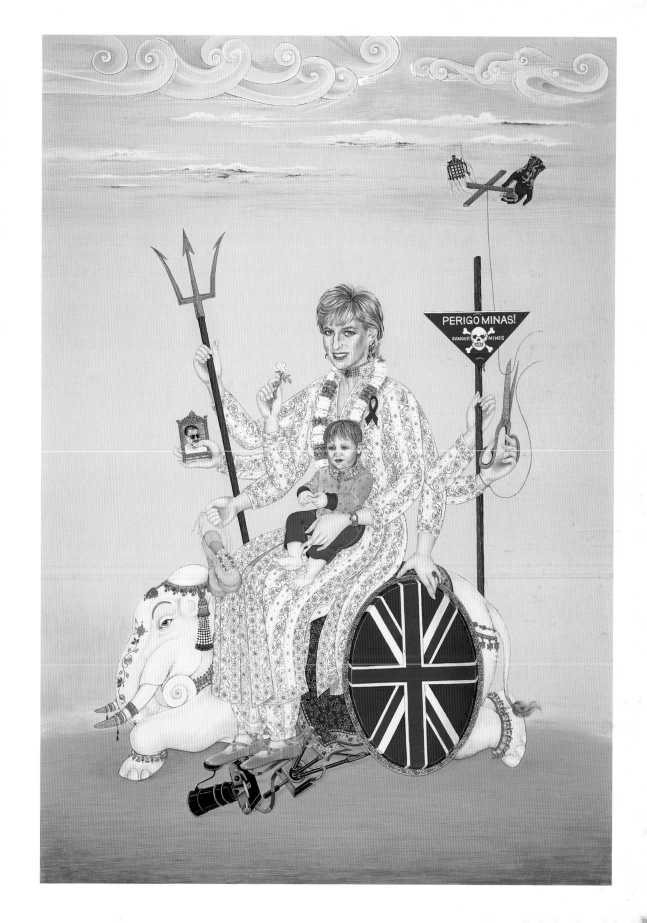

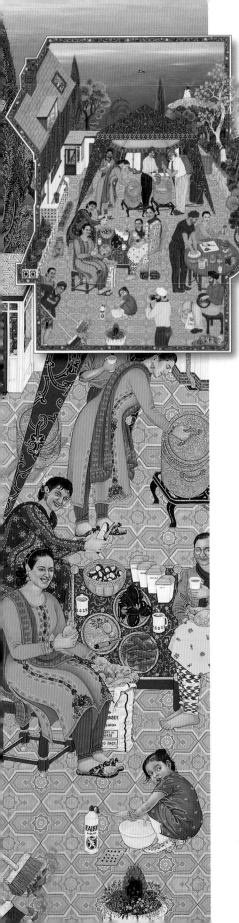

Diana's iconography a hybrid of Britannia, Madonna and Child, and the Hindu goddess Durga (the English rose she holds is thus shown to be just one aspect - rather than the whole - of her identity), but the image's meaning shifts according to the cultural identity of the viewer. So, the white elephant on which Diana sits, in the Indian tradition has a positive significance as the symbol of compassion; but in the western tradition it has pejorative connotations, signifying something redundant and wasteful. The picture's status is located in the interstices between satire and religious icon, and between East and West, and ironically criticizes all processes of cultural stereotyping through the reduction of complex identities to emblems.

The insertion of Hinduism and Islam as well as Christianity into this icon of Britishness (or Englishness), asserting that even a figure as rarefied and supposedly 'pure' as Diana, Princess of Wales has a multiple, multicultural identity, is a telling demonstration of how the Twins' art challenges and confounds any simple recourse to binary opposition in the articulation of cultural identity. Central here is the undermining and dismantling of the conventional antithesis of western to non-western art and culture. Much recent art history, following the pioneering lead of Bernard Smith's *European Vision and the South Pacific* and Edward Said's *Orientalism*, has analysed this relationship, particularly in terms of its historical correspondence to the practices and ideologies of colonialism and imperialism, whereby non-western art was conventionally placed in the category of craft, and thus regarded as implicitly inferior to the art of the western academic tradition. Indian miniature painters were deprecated: 'the native painters of India do not possess a genius for fiction, or works of fancy; they cannot invent or even embellish, and they are utterly ignorant of perspective; but they draw figures and trace every line of a picture, with a laboriousness peculiar to themselves'. The very medium adopted by The Singh Twins, therefore, is a knowingly informed reflection upon this historical discourse, and to this extent their work may be said to be historicist. More important and remarkable, however, is the fact that they are able to offer such a critique from a position within art practice.

It is impossible to categorize their art as either British or Indian: it dispenses with such simple classifications and renders them unworkable. It is important that this hybridization is achieved through the Twins' acute awareness and exploitation of both British and Asian traditions and histories, coupled with a perceptive eye on the political effects and operations of multicultural heterogeneity in the world beyond art, whether this is manifested as the transformation of Indira Gandhi into a tank-driving hydra with the heads of Thatcher, Clinton and Churchill in *Nineteen Eighty-Four* (detail p4), or in the strikingly effective strategy employed in *O Come All Ye Re-eds*! (page 9), of rendering such a jingoistically partisan English event as a Premiership soccer match in the form of a Mughal miniature.

Similarly, if the love of decoration and exuberant attention to detail derives from a thorough familiarity with the Indian miniature tradition, it also displays a sure knowledge of Victorian art, particularly the Pre-Raphaelites. The meticulous care bestowed upon the rendering of surface detail, pictorial content and symbolism is almost Ruskinian in its devotional attitude to the apparently mundane. The surfaces of their paintings are abundant with detail, yet nothing is lost or wasted: as with Pre-Raphaelite painting, all parts of the painted surface, and all represented subjects are meant to be seen with equal clarity. *All Hands on Deck* (left) enables us to reconstruct precisely the preparation of ingredients for the dishes comprising the wedding feast: the strategic combination of western and Asian perspectival systems facilitates the fullest description of each aspect of the subject-matter, from the bird's-eye views of plates of herbs and vegetables, to the profile view of a bottle of washing-up liquid, to the carefully articulated recessive sequence of precisely observed flowers and shrubs that border both the space of the terrace and the picture of it.

In both the making of their work, and in its iconography, there is what can only be termed a devotional respect for materials and the sensory world. Such heightened sensitivity to the materiality of the artistic language employed may, in one sense, be said to comply with Jameson's criteria for Post-modern culture. Yet, in the Twins' case the materiality of language does not arise, as Jameson argues, from a separation of the signified from the signifier, rather the reverse: it is produced from a multiplying and polysemic overloading of the signifier emanating from the hybridized context of British-Asian culture. Consider the language of hands in *Nyrmla's Wedding II* (page 7) and the way they are represented in this painting to articulate a relationship between touch and sight. From the hands of the dancing girl holding her hem (whose dancing movement

seems to generate the sinuous arabesques and curves of the composition), wittily parodied by the cat pawing her veil, and the hands of the boy beating her rhythm, it is in the realms of materiality and sense, concentrated in the representation of hands, that the substance of the image lies. At the exact centre is the ritual ceremony of painting patterns of *mehndi* on the hands of the bride-to-be, who raises one hand in a gesture that unmistakeably recalls that of blessing. The flatness of the patterns on her palm corresponds to the flat patterns on the carpet and walls, to set up an elegant reciprocity between the Twins' act of painting her hands and their painting the picture that is a record of it. The delicate, precious gentleness of touch shown in cradling the hand to be painted is answered by the beautifully poised weight upon the artist's shoulder of the hand of her sister. The latter in her other hand holds a camera, significantly overlaid upon the background figure holding a camcorder: alternative mechanisms to painting for visual representation and recording, these also point up alternative alignments between the tactile and the visual. Epitomizing the sense that pervades the picture, of loving respect for the material, sensory world, is the advancing figure in the background, who holds in her hands a large abundant bowl of fruit, no doubt to be prepared and consumed with the hands, and with the same care and pleasure as the painting of the *mehndi* patterns. The sense of the sacred in this correspondence between sight, touch and painting is highlighted in the top left scene of the marriage ceremony.

Yet, the compositional harmony and elegance of the interior scene leads inexorably to - and is to be contrasted with - the grossly painted, leering clown face of Ronald MacDonald, whose hands, placed against a background of industrialized waste and environmental devastation, are poised on the edge of the window/picture frame, seemingly about to interrupt and contaminate the sacred interior spaces. The contrast is not so simple, of course: the prominent placement of the children's western toys and the juxtaposition with the betrothed's painted hands of the electric socket (the yellow of which exactly matches that of MacDonald's outfit) makes it clear that this harmonious domestic environment is located in, and to some degree born out of and dependent upon, the larger context of a Postmodern, global, consumer society.

Might the contrast made explicit here be analogous also to the contrast between Modernism and Postmodernism in the Singh Twins' art? We might justifiably read this image as a rejection of a Modernist, industrialized, competitively capitalist individualism, personified by MacDonald, in favour of a celebration of the local, the traditional, the culturally hybrid, and the contingent. We might also see it as contrasting two facets of

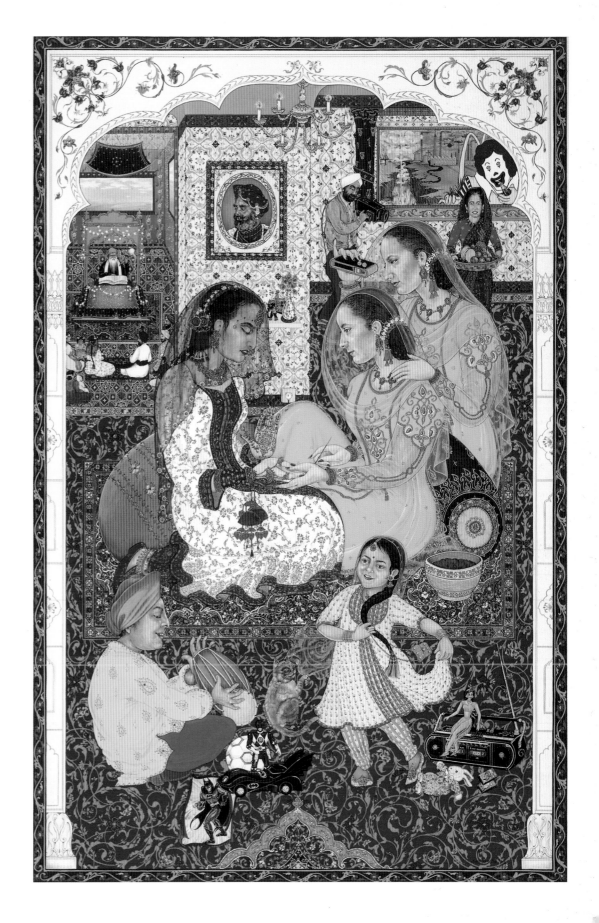

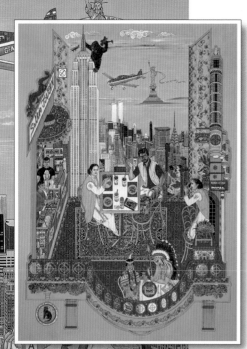

Postmodernism: the richness of the expanded social sphere of multiculturalism against the barrenness of uncontrolled consumerism. Jameson concludes his essay on a questioning note, by observing a similar contrast: 'there is a way in which postmodernism replicates or reproduces - reinforces - the logic of consumer capitalism; the more significant question is whether there is also a way in which it resists that logic.' Works such as *Nyrmla's Wedding*, in its special contingent way, appears to offer an affirmative answer.

Issues of cultural identity, whether those of British-Asianness or of twin-ness, which subtend, to a greater or lesser degree, the whole foundation of the Twins' art, are explored perhaps most acutely through such representations of private, domestic Anglo-Indian life. Yet, it is critically insufficient to seek a "key" to the Twins' work by recourse to that fashionable Postmodern term 'identity'. As they themselves have stated:

> Ultimately … our artistic strategy is defined by a sense of responsibility to look beyond personal issues of identity - towards exposing wider cultural prejudices and highlighting other concerns of more global significance. The desire to make a real difference through our work has fuelled our determination in establishing an international profile that demands acceptance on our own terms - creating a recognised platform for serious debate which has meaningful impact in challenging pervading social, political and cultural attitudes.

Hence, whilst *Manhattan Mall* (left) questions the generally accepted notion of America as the 'land of liberty and freedom', the *Facets of Femininity* series (pages 33-41), made after Rossetti, and the works done after William Blake's apocalyptic imagery (pages 30-31), for example, explore how cultural attitudes are invested in key works of British art and in the history of art itself. Their adaptations of Rossetti's *Blue Bower* (page 33 centre) constitute a startling and revelatory critique on that picture's embedded cultural stereotyping of orientalized femininity, and the way that its historical significance has rested upon its allusion to, but ultimate subordination of, eastern culture. Paul Gilroy has analysed the 'double consciousness' at the core of black identities in the Atlantic world, in terms of the way this is produced through the discourse and history of culture and cultural studies: 'enquiries should be made into precisely how discussions of 'race', beauty, ethnicity, and culture have contributed to the critical thinking that eventually gave rise to cultural studies'. It is just such an enquiry that The Singh Twins make in their later works, by which they stake their claim to a key place in contemporary British art: by engaging in a radical, reflective project to restore contemporary art to its roots in tradition and history, but simultaneously to undermine any complacent expectations concerning what those traditions and histories comprise.

Footnotes

i. *Outlook -The Weekly News Magazine*, Stree, Collectors Edition – Modern Indian Women, 'Duplex Minds, A Culture Tango', Amrit KD Kaur Singh, pp 68-73.

ii. See especially Jean-Francois Lyotard, *The Post-modern Condition: A Report on Knowledge*, trans Geoff Bennington and Brian Massumi, Manchester, Manchester University Press, 1984.

iii. Fredric Jameson, 'Postmodernism and Consumer Society', in Hal Foster ed, *Post-modern Culture*, London, Pluto Press, 1985, pp 111-125, quotation p 125.

iv. Craig Owens, 'The Allegorical Impulse: Towards a Theory of Postmodernism', 1980, in Donald Preziosi ed, *The Art of Art History: A Critical Anthology*, Oxford and New York, Oxford University press, p 321.

v. Julian Spalding, 'Introduction' in *Twin Perspectives: Paintings by Amrit and Rabindra KD Kaur Singh*, Liverpool, Twin Studio, 1999, p 6.

vi. Bernhard Smith, *European Vision and the South Pacific*, New Haven and London, YaleUniversity Press, 1985, Edward W Said, Orientalism, Harmondsworth, Penguin Books, 1978.

vii. Michael Symes, An Account of an Embassy to the Kingdom of Ava sent by the Governor-General of India in the Year 1795, London, 1800, p 252, quoted in Mildred Archer, *Company Drawings in the India Office Library*, London, HMSO, 1972, P 4.

viii. Jameson, op cit, p 125.

ix. *Outlook -The Weekly News Magazine*, Stree, Collectors Edition – Modern Indian Women, 'Duplex Minds, A Culture Tango', Amrit KD Kaur Singh, pp 68-73.

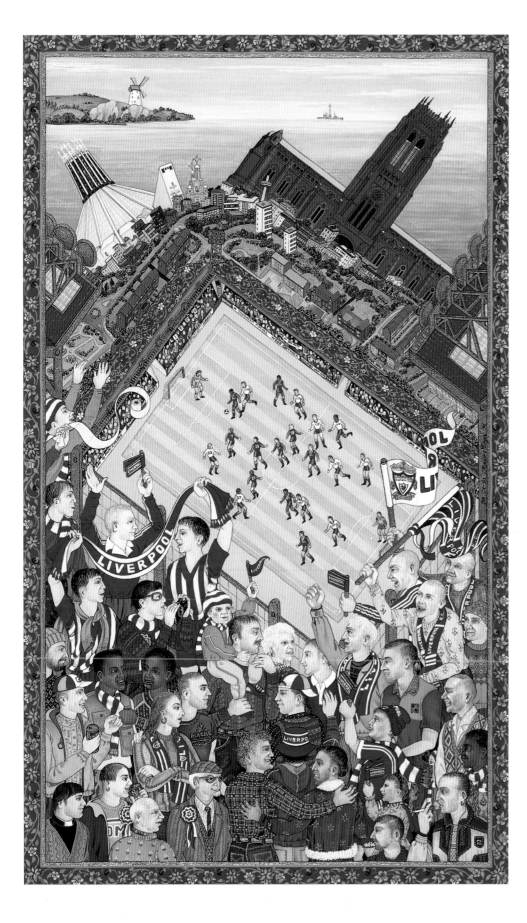

Dr Geoff Quilley

is Curator of Maritime Art at the National Maritime Museum, Greenwich. Before that he was Lecturer in History of Art at the University of Birmingham and subsequently at the University of Leicester. His interests focus upon eighteenth-century Britain and more widely upon British art, imperialism and national identity. He has published articles on various aspects of British art and the maritime nation, co-edited (with Kay Dian Kriz) An Economy of Colour: Visual Culture and the Atlantic World, 1660-1830 (Manchester University Press 2003) and co-convened the major conference Art and the British Empire at Tate Britain in 2001. He curated the international exhibition William Hodges 1744-1797: the Art of Exploration (National Maritime Museum 2004) and is editor (with John Bonehill) of the exhibition catalogue (Yale University Press in association with the National Maritime Museum 2004). He also curated the contemporary art exhibition The Illuminated Calvino (2001), and is currently completing a book, Empire to Nation: the Image of the Sea in British Art 1768-1829.

'The Intersection of Power and Meaning': Art and Politics in the work of the Singh Twins

Veronica Sekules

The Singh Twins are sitting side by side in a narrow armchair absorbed in the social scene. The interior is opulently decorated and grand, bedecked with portraits, gilt mirror, cornice mouldings and chandelier. An Indian girl dressed in tartan begins to dance before the assembled company. Gertrude, Lady Iqbal Singh watches her, while conversations around the room continue between elegant groups of Europeans and Indians. In a garden scene in front, the Twins' father, Dr Karnail Singh is planting a tree, a ceremony reserved by the laird, Lord Iqbal Singh, as a customary mark of respect for guests. While an uninitiated viewer might just guess at the subjects portrayed here, the artists' commentary is essential in order to decode the picture accurately. It represents a seminal social moment in an extraordinary cross-cultural phenomenon: the meeting in a quasi-court scene at the Lord Iqbal's Scottish residence of these influential, educated and well-to-do Sikhs, Swiss and Canadians. It is both a 'conversation piece' in the English 18th century tradition and a *Durbar* from Indian high culture. (cf: ill.10, Stronge 1999, 20). The painting (page 24) forms part of a commissioned series, commemorating the contribution to Sikh-Scottish relations of Iqbal Singh, a nobleman, whose enthusiasm for his adopted country resulted in the invention of The Singh tartan, and the translation of poems by Robert Burns into Punjabi.

The painting and the rest of this *Iqbalnama* series, simultaneously tackling issues of assimilation and cultural difference, is also a seminal one in The Singh Twins' repertoire as in it are exemplified so many aspects of their interests, background, tastes, talents and social context. Every aspect of the rich detail and incident has been carefully considered and accounted for, over months of research and preparation. Spatial compositions, decorative conventions and painting techniques, as in so many of the Twins' works, are rooted in older Indian art, especially courtly works of the Mughal period and the historical arts of the Sikh kingdoms. But they are far from being nostalgically historicist. Every aspect of their symbolism has contemporary meaning and the images are also intensely political. While the *Iqbalnama* works are celebratory of the success, wealth, nobility and comfort of an immigrant lord, at the same time, the artists are pointedly aware of the irony of some of the role reversals and incongruities. *To the Manor Sporran* (page 21), itself an ironically punning title deriving from the tabloid press, shows Lord Iqbal grandly taking tea before his castle to the tunes played by a subservient piper, in a manner which would have been performed historically in reverse, by an Indian servant for the British sahib. Two portraits in the series, again use a combination of tabloid press titles and Mughal miniature traditions to highlight aspects of cultural singularity and difference. *Laird Singhs his Tartan's Praises* (page 23), isolates the Lord's figure in the customary pose of a Mughal nobleman, showing him in ceremonial tartan. The other, *All for Burns and Burns for All* (page 22) presents him in heroic and eccentric style against a rosy tinged horizon, balancing a pennant emblazoned with the head of Robert Burns on the small island he purchased and renamed in the poet's honour. Here he appears as the master of a tiny land set within a broad sea, but it somehow conveys both the hubris of the conqueror, and a humble tribute and offering to his hero.

Those very dichotomies, the tensions between authority and submission, master and servant, native and foreign, echo what Homi Bhaba has described as hybrid forms of cultural identity, formed by the intersection of power and meaning (Bhaba, 1990, 312; 1994, 175). The complex history between the

British and the Sikh social élite underly these pictures, but also the artists' role in conveying such complexities is extremely knowing. Even the play in their work on notions of Post-Modern and 'Past-Modern', the latter being how they have defined their work, echoes the shifting discourse of post-colonial 'contramodernity', the representation of the past in the present, the aspirational alongside the documentary.

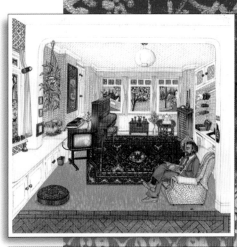

The aesthetic impact of their work has its own complexities too. On account of its bright colour, rich pattern and surface compositions, it has been often described 'decorative'. Superficially this may be the case, but this notion needs unpacking. Their use of pattern, colour and spatial arrangement, conforms to a system, to a convention, a particular and very long history of artistic representation in South Asia. Its traditions and skills were adopted by them for political and patriotic reasons. From a point in the 1980s, while they were still studying art at University, having heard from their tutors about artists such as Gauguin and Matisse turning to exotic cultures for inspiration, they turned to their own background in India and found a profound and neglected artistic world of miniature painting, full of resplendent imagery and rich symbolism. They have written and spoken about the way in which they were irresistibly drawn to explore their native art forms and subsequently to adopt Indian dress and a shared identity exploiting their 'twin-ness'. One of their first series of works *Daddy in the Sitting Room* depicted their father, and mentor, seated in their living room, successive versions each becoming more drenched in Indian pattern and vibrant colour (right). Again, the story has already been told about the downgrading of these images - and of the theses which explored the influence of non-European art forms on the development of western modern art - submitted for their finals exams. Incredibly the artists are still, many years later, fighting to reinstate the first class degree mark that was awarded by their tutors, but categorically denied them by an exam system which failed to recognise its own racism (Past-Modern, 2002, 46-48). In western art school terms, they were following the canon in looking for inspiration to the arts of the East, but largely because of their cultural background and affiliations and their emphasis of their dual identity as twins, their rightful accolade was denied them. There are also a number of wider issues here. No doubt, despite the well established and celebrated existence of Gilbert and George, Langlands and Bell, and other collaborating pairs of artists, the bureaucracies of art school would not allow them the license to fuse aspects of their identity, even though their works are, even now, individually signed. But much more serious is the persistent and currently all pervasive hegemony in the art world which favours a particular kind of gritty contemporary globalisation. Despite growing interests in widening perspectives, greater inclusion of what have been previously regarded as minority cultures, ideas in contemporary art still spread internationally mainly in the context of shows selected by European or American trained curators in big white walled galleries or in alternative industrial or distressed spaces. The new-century Biennale phenomenon, favours large-scale painting and installation, politicised multi-media and video, with a tendency towards the enigmatic open-endedness of 1990-2000s Conceptual Art, a concern with environmental stress, war zones, displaced peoples and problematic identity. Paradoxically, this international exhibiting culture irons out difference and eccentricity, in the interests of a dominant consensus about what and who makes art look good and what sits well together, as well as what is topical and worth protesting about.

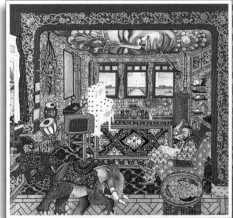

Although many of the issues, to do with war, greed, identity and cultural change, are strikingly present in the Twins' work, during much of the 1990s, they have found themselves countering this hegemony, at least aesthetically, in that their work is small scale, hand crafted, highly detailed and deeply symbolic. In spite of the influence of well known advocates in the UK of traditional Indian art, like Howard Hodgkin, and in spite of their own persistence in attempting to widen the cultural and aesthetic frames of reference, they have suffered an older form of racism, the marginalising stigma of Orientalism (Said, 1978/2003, 4-9). The exotic, the decorative and colourful, the pattern-making and the craft of their work, has made it seductively accessible and accordingly, their art has been more readily appreciated for its decorative qualities and technical virtuosity than for the force of the messages which it is conveying.

Sikh women growing up in England often struggle to straddle the cultural borderlines between their religion and family and the westernization of their education. Kathleen Hall's study of Sikh youth in Leeds in the 1980s attests to their confused feelings as they try to reconcile two worlds (Hall, 2002, 148 ff). In contrast, the Twins must have enjoyed an unusual degree of security, in spite of the fact that their own family history went through a familiar cycle experienced by trans-nationals, of optimism and enthusiastic adoption of their new native customs, followed by a certain cynicism as initial hopes of tolerance and integration were not fulfilled. While they are proud and loyal advocates of their Indian-Sikh heritage, and express that outwardly by wearing traditional *shalwar kameez* as a matter of course, their Convent school education and degrees in comparative religion gave them a wide ranging

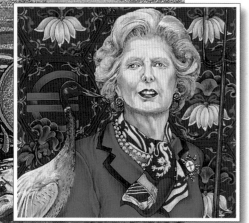

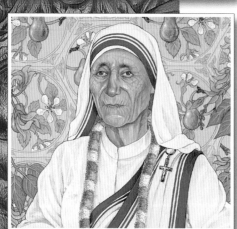

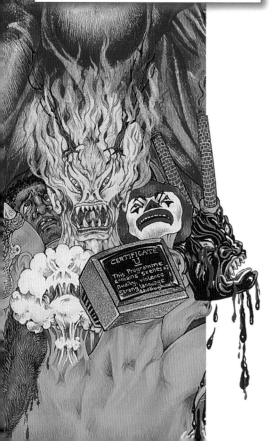

intellectual and cultural framework for their beliefs and this is also often evident in their work. For example, in the case of a commission in 2000 to rework any of the paintings of William Blake, they painted *The Beast of Revelation* (page 30) and *Paradise Lost* (page 31), reinterpreting both in a modern idiom. They demonstrated through personifications, symbolism and powerfully monster-laden imagery, the evils of political corruption, financial speculation, and accelerating scientific progress motivated by greed and lust for power. *Paradise Lost*, a reinterpretation of Blakes *Temptation and Fall of Eve*, reconfigures the traditional Christian image of Eve as the active temptress, as herself beguiled. Entwined in the serpent's grip, she bites the hand grenade and becomes both a victim of evil forces, and a conduit for them.

For the series *Facets of Femininity* (pages 33-41), for which Dante Gabriel Rossetti's *The Blue Bower* of 1865, was the starting point, eight portraits of female icons embody and challenge stereotypical qualities particular to women. The choice of women is governed not by any conventional programme. One might, for example look for a reworking of traditions of female personification, like the Virtues and Vices, or the Seven Liberal Arts, but these are not. Rather, this is a 'Vanitas' series which both celebrates and judges its subjects, contemplating the fallibility of beauty, power and wealth. It is also international (two women originate from the United States, three from Britain, one from USA-Greece, one from Argentina, one from Eastern Europe) and explores the impact of contemporary media-driven values, as all the women have variously fallen victim to a prurient publicity industry. Alongside undoubted iconic figures whose fame has stood the test of time, like Eva Peron, Marilyn Monroe, Maria Callas and Princess Diana, are two pop idols whose impact may prove to be less enduring: Madonna, and Geri Halliwell, the latter exemplifying a particularly shallow self absorption and attention-seeking. Only Mother Teresa stands apart from the rest, as the one figure who represents selfless caring for others and self sacrifice, intentionally making the vanities and glossy concern with appearance of all the others appear all the more superficial. The choice of attributes and symbols, which are used to emphasise aspects of the womens' characters and personal histories, relate to a particularly cosmopolitan artistic repertoire, reinforcing the hybridity of the subjects' or the artists' cultural associations and emphasising the multi-layered cultural milieu in which the paintings will be viewed and understood.

Cultural politics is even more the sphere within which the Twins operate for the *Sportlight* (pages 59-79) series of ten paintings, commissioned as part of the celebrations for the Commonwealth Games in Manchester in 2002. This is far from being a conventional sport-promotion exercise, but the global context allowed them free rein to explore questions of ethnicity, and the commodification controlling sporting identities. The Twins also used the paintings to explore a whole series of essential qualities and ideas which are inextricably interwoven in the culture of sport, including: physical prowess, virtuosity, self-presentation, vanity, pride, gender identity, spectacle, violence, rivalry, war and combat, greed, media promotion, product endorsements, and entertainment. The allegorical images perform for contemporary sport something of the strongly moralizing and sharply satirical role which William Hogarth's 'Election' paintings and engravings did for 18th century English politics. There are also familiar echoes from Indian miniature painting which serve all the more to sharpen the ironies of these pictures, as they use conventions for portraying the wealth and spectacle, the pleasures and pastimes of the social élite to elevate these popular heroes to iconic status. That the Indian paintings reference primarily a courtly world and that contemporary sport is played within a commercial and media-driven circus is a point not lost on the artists, but used to poignant effect.

There's No Business Like Show Business (page 71), represents the boxer Prince Naseem Hamed in the manner of a sporting hero from Mughal Court art, but in very much more extrovert and value-laden contemporary mode as an arrogant swaggering buccaneer dancing on his cushioned throne. The Twins' text points to the contrasts between this figure and that of Mike Tyson whose forlorn handcuffed image, wrecked by his own misdirected violence, stands upon a pool of blood and money which spills out of an Attic Greek vase, intending to allude to the long history and precarious rewards of the combat sports. Both paintings highlight the enslavement of the fighters to a regime bounded by violence and terrific media gains and losses.

Violence is altogether a persistent theme in this series of paintings, underlying six out of the ten. It is most explicit in the *The Killing Game* (page 61) and *Battle of the Giants* (page 67), two paintings which are strikingly based on Mughal boar and elephant hunts, and conceal an armoury of techno-weapons, media machinery and prize rugby teams within their skins. The role of the media in fuelling xenophobia and inter-cultural violence is the focus of *In Action-Replay* (page 75), which parodies some of the ways in which sport reporting is biased against certain opposing teams representing foreign countries. A symmetrical composition (a characteristic of the arts of war in Indian Miniature painting, as well as from the European Middle Ages)

allegorises a pseudo football game formed by warring hooligans from opposing German and Argentine teams. They are dominated by politicians and military leaders from the Second World War to the Falklands, so above them we have Hitler and General Galtieri on one chariot, opposing Winston Churchill and Margaret Thatcher, with the referee in the centre stopping the 'game' with a red card.

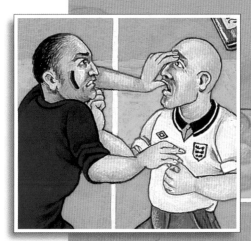

Ice skating is a leitmotif for the yearnings and aspirations of the central character in Monica Ali's novel 'Brick Lane', a shy immigrant Muslim woman from village Bangladesh who settles in East London for an arranged marriage to a much older man. For her it becomes a symbol of Western physical and artistic spectacle, for license to display the body, for graceful and emotionally transporting dance. As the story ends with her growing westernisation and independence from her culture of origin, ice-skating provides a final redemptive image of freedom and fantasy. There is an equivalent dual allusion to complementary and opposing values of East and West in the painting, Dance on Ice (page 79), representing Torvill and Dean as an epitome of a romantic artistic partnership at the height of their international career at the Winter Olympics of 1984. The Union Jack waving fans and scoreboard are intended to emphasise the competitive context of the skaters' British National identity, whereas the composition, reworking a well-known Indian dance painting, evokes the gentler grace and virtuosity of their craft. Altogether more aggressively representing a complex cross-cultural identity, in Dressed to Kill (page 69) Venus Williams appears as a Black woman, and as an American, via the Stars and Stripes flags, the map and commercial credits at her feet. The composition is also based on an Indian model, but here its origin, representing female hunters, highlights a somewhat predatory intention. Her role as a sportswoman is also ambiguous. Only her tennis racquet, from which she turns away, represents her sporting prowess. Her pose is more that of a model and the picture is dominated by the host of women, mainly Black, paying homage to her glamorous figure and incapacitating shoes. All the women are shown in thrall to the powers of fashion and brand identity, commodifying sport and people alike.

The Twins have a privileged position as artists in that they situate themselves both within and without the many-layered cultures they are involved with, operating as participants, observers, critics and social commentators. The multi-layering of references, particularly well developed in the Sportlight series, recalls Homi Bhaba's notion of the 'interdisciplinarity' of the shifting ground of 'knowledges' which characterizes the field of cultural difference (Bhaba 1990, 312-3). Over the past ten years or so, observers of the world changed by ever increasing numbers of migrant peoples - including Homi Bhaba (1990, 1994), but also Arjun Appadurai (1991) and Angela McRobbie (1994) - have observed an increasing hybridity, a multi-layering of memory, experience and cultural reference which can be expressed as a reformation and enrichment of social practices. The links and relationships between people places and culture have been shifting constantly. Hall (2002) and Giddens (1991) both commented on the fact that 'tradition plays a new role as it is ruptured from its safe location in time and space'. It is debatable whether cultures have ever been firmly located in place and linked immutably to people in any fixed way. The history of the world has for centuries been marked by migrations and by cultural change. What is new about recent phenomena is the accelerated pace of change which undoubtedly increases the levels of engagement, and also the greater scrutiny, and indeed confusion created by media and communication technologies and the proliferating forum they provide for public discussion.

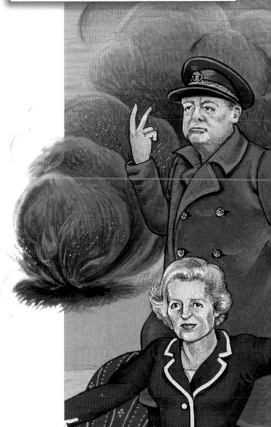

The globalising instruments of commerce and the media are constantly alluded to in the Twins' work, and on account of their ongoing interest in the factors which blur the distinctions between cultures, a host of questions arise about beliefs, morals and points of view. On whose behalf do the paintings comment? What powers do they unleash and what new areas of debate do they present to their viewers? By combining different cultural elements, are they engaging forces of resolution or forces of difference, a synchronic or a diachronic process? At one level, the phenomenon they are engaging with, is an unequal struggle between individual cultural protagonists, whether sportspeople, actors or princesses, against a global accumulation of commercially and politically driven interests which are bent on self-perpetuation. At another, they are highlighting one of the paradoxes of globalisation, that it is both becoming easier to combine elements from different cultures, more 'territory' is available for exploration, but it is also becoming increasingly difficult for boundaries to be crossed without encountering heightened sensitivities to cultural and historical difference and specificity. According to Cesare Poppi's theorisation of the process of ethnicity within a global context, 'Ethnicity in the post-modern age is therefore expressed not so much in the internally context-specific diversities between cultural formations, but between the externally context specific differences across cultures'. For there to be exchange and location of cultural difference on equal grounds, he maintains, there has to be a systematic articulation of the differential characteristics between different sectors, which widens in a global context at a commensurable rate (Poppi, 1997, 294). However, a congruence of

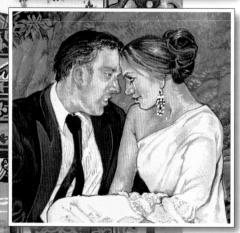

unequal forces on unequal terms, is not propitious to the production of a clear sense of ethnicity, nor can boundaries be negotiated in order to contest issues of difference within a hegemony which is still dominated by Western politics:

> 'Here, liberal-minded critics find themselves caught between the rock of exhausted symmetries predicated on a universalism no longer suitable as a 'grand narrative' ('your freedom ends where mine begins') that the process of globalisation has finally made both hopelessly porous and ferociously transitive, and the hard place of the new 'cultural racism' (Balibar and Wallerstein 1991), whereby different people should indeed be allowed to pursue their own cultural values…'. (Poppi 1997, 296)

Unwittingly, the Singh Twins became victims of the new 'cultural racism' over one of the paintings in the *Sportlight* series, an experience which made it very clear furthermore, that there are no 'grand narratives' and that cultural values are by no means universally shared even within a single country or belief system. It also demonstrated how variable is the transfer of meaning in the visual arts, how dangerous it is for viewers to rush to conclusions about meanings without proper research and reflection, and what a damaging role the press and media can play in perpetuating and magnifying mis-understandings. The painting in question, entitled *From Zero to Hero* (page 65), shows David and Victoria Beckham and their eldest son Brooklyn apotheosised in a manner which draws upon traditional artistic conventions used to depict the gods and demons of Hindu mythology. The painting was intended as a moralising and ironic narrative, pointing out the follies of social aggrandisement and commercialism, showing Beckham's many hands holding the products he endorses and with the family enthroned, as in their home 'Beckingham Palace'. The tabloid press jumped to unwarranted conclusions about the painting, misinterpreting the symbolism, and assuming it to show the Beckhams as specific Hindu deities. This quickly inflamed a public row, as a consequence of which the Twins received admonishments and even death threats from individuals of the Hindu community who felt the image was disrespectful to their religion.

Despite its unfortunate consequences, the *From Zero to Hero* episode demonstrates the extent to which tempers can be inflamed once the arena for discussion of the powerful messages of art transcend the confining walls of the art gallery. While this painting was misunderstood, the fact that the Twins' art can become a powerful political tool is something they welcome, and indeed, intend. *The Art of Loving* series (pages 43-57), plays most subtly on relationships and tensions between the aesthetics, the moral values and the popular culture of East and West, using an art form well developed in Indian art as a means of celebrating poetic sensibility, the *Ragamala*. In the Twins' hands this tradition has been adapted as a means of sharp exposure of Western media-driven values. Several of the images present a version of the 'World turned upside-down', a phenomenon which occurs in Indian popular art and in Medieval art of western Europe, whereby the message normally associated with a given form of representation is reversed. In historical periods, the reversal is portrayed by means of animals enacting the roles of humans. In the Twins' images, it is media figures who act out the scenes. Thus, the form of *ragamala* which is normally reserved for celebration of the spirituality of union and to recall private moments enjoyed between lovers in seclusion, is used in *Star on a TV Show* (page 49) to expose the trivialisation of relationships through the public and media-led obsession with the public display of celebrity private lives. In *Funky Weekend* (page 51), a negligee-clad blonde revels in her pampered solitude, rather than agonising over the separation from her husband, which would be the normal emphasis of the *ragas* for this scene, which were intended to empathise with the pain of separation.

Funky Weekend and several others in the series, break out of the traditional frame within a frame format of Indian miniature painting to which the Twins had largely adhered hitherto. The narrative is carried in stepped form as the blonde's house is opened out in a diagonal across the picture, suggesting the passage of time between her expelling her husband from the front door at the top left of the picture, and to her retreat to her luxurious inner sanctum towards the bottom right. In each one of these paintings, including those like *I Feel Pretty* (page 50), and *Solitude* (page 55) which have retained the framed format, combinations of intense colour and shading, dense pattern and compositions, have been used more freely and inventively than in previous series. The loosening of adherence to historical prototypes has made the work both more open-ended in terms of its cultural allusions, and more sharply directed visually. Colour, spatial arrangements which lead the eye into the heart of the pictures rather than across the surface, and intense use of pattern have been used to enhance a sense that these figures are trapped in a suffocating and intense world with no freedom from constraint, or empowerment. *Steppin' Out with My Baby* (page 57) is one of the most intensely drenched in colour, the colour of *haldi* (turmeric). A picture of

Madonna features in the background, displaying her *mehndi* patterned hands, having appropriated this traditional form of adornment as a fleeting fashion statement. The main subjects of the painting are a little Indian girl and an older Indian 'Odalisque' or quasi-Venus figure, admiring herself in a small mirror. They are both dressed in Indian clothes and surrounded by Western trappings of manufactured and consumerist beauty. The scene reaches the heart of the Orientalist conundrum, the creation of inequality through the overvaluing and appropriation of style within a Western canon (Said, 1978/2003, 11-15; 150). We are being presented with an image of style without substance: ethnic customs and signs of identity being taken out of context and literally refashioned. But the question is, whose culture is being the most transformed or the most violated by these exchanges of values? Are changing fashions entirely superficial, or are they outward signs of a potential for deeper cultural understanding?

Through their use of symbolism and complete mastery of their image-making skills, the Twins have considerably deepened the level of discourse about the role of the media, pointing to the superficialities and dangers of a media driven culture and holding a mirror to the world which reflects some of its follies and vanities. The role of the mass media in identity-formation has been acknowledged as an inescapable facet, especially of youth culture (Hall 2002; Appadurai 1991; McRobbie, 1994). Hall, in particular has considered the potential role of the media in sharpening discourses about cultural difference by providing material for dialogue and reflection in which people develop a consciousness of the separateness of their identity. Despite the potential for the media to transform space, dissolve distance and create cultural affinity between groups that live far apart, Sikh identity, she maintains, has been firmly anchored by the media on British soil, whereas popular culture has provided resources for creating hybrid identities which may eventually result in transformations in the dominant ideology or in new ways of conceptualising social difference (Hall, 2002, 146-7). In the case of The Singh Twins, the notion of hybrid identity is one which they have created and manipulated extensively. Their background and education has given them multiple perspectives: as British Asians, as female artists steeped in a highly literate, liberal, philosophical and politically astute culture and as twins engaged in a joint project securely located within a supportive family. Politics are at the heart of their work: a celebration of the rights to hold true to spiritual values, histories and traditions, questions of race and ethnicity. There is also a concern with the relationships between aesthetic and political change, a play with the shifting interpretive balance held by the artist whose work engages with hybridity (Hall, 2002, 127; 140-145). However, the tools for making and the conventions for viewing in the visual arts, have enabled a sharpening concentration on the links between the appropriateness of the medium and the force of the message. Their work manages to reference an ancient visual tradition, but also to be highly committed to a series of personal and contemporary agendas. For Amrit and Rabindra, their own multiplicity of perspectives has empowered them to shift the ground for the debate away from questions of cultural diversity and towards a greater concern with deeper issues of morality, over the rights of appropriation of images and the manipulation of signs of identity, which both include and transcend issues of nation and belief.

References

Monica Ali, 2003, *Brick Lane*, London, TransWorld.
Arjun Appadurai, 1991, 'Global Ethnoscapes: Notes and Queries for a Transnational Anthropology' on Richard G. Fox (ed) *Recapturing Anthropology: Working in the Present*, Santa Fe, School of American Research Press.
E. Balibar and I. Wallerstein, 1991, *Race, Nation, Class: Ambiguous Identities*, London, Verso.
Homi Bhaba, 1990, 'DissemiNation: time, narrative and the margins of the modern nation', 291-322 in Homi Bhaba (ed) *Nation and Narration*, London, Routledge.
Homi K. Bhaba, 1994, *The Location of Culture*, London and New York, Routledge.
A. Giddens, 1991, *Modernity and Self-Identity: Self and Society in the Late Modern Age*, Cambridge, Polity.
Kathleen D. Hall, 2002, *Lives in Translation, Sikh Youth as British Citizens*, University of Pennsylvania Press.
Angela McRobbie, 1994, *Postmodernism and Popular Culture*, London, Routledge.
Past Modern: Paintings by the Singh Twins, 2002, Publications Unit, Southampton Institute.
Cesare Poppi, 1997, 'Wider Horizons with Larger Details: Subjectivity, Ethnicity and Globalization', 284-305, in, Alan Scott (ed) *The Limits of Globalization*, London, Routledge.
Edward Said, 1978/ edn 2003, *Orientalism*, London, Penguin.
Susan Stronge (ed) 1999, *The Arts of the Sikh Kingdoms*, London, Victoria and Albert Museum.
Twin Perspectives. Paintings by Amrit and Rabindra KD Kaur Singh, 1999, Liverpool, Twin Studio.

Dr Veronica Sekules
is founding head of education and research at the Sainsbury Centre for Visual Arts, University of East Anglia, Norwich, where she was formerly a curator. During 2004-5 she is also working for Tate Britain as project manager for a regional museum partnership project funded by the Department of Culture, Media and Sport. She was trained as an art historian, specialising in the middle ages and 20th century art and is widely published in these areas. She is author of Medieval Art, published by Oxford University Press (2001). She has an MA in education and is an active educational researcher and writer. She is a Fellow of the Society of Antiquaries and of the Royal Society of Arts. She has been a member of many art and heritage committees. She has been invited to work as a consultant, to lecture and run projects and workshops for teachers and museum educators in the UK, Italy, France, Sweden, Bulgaria and Romania.

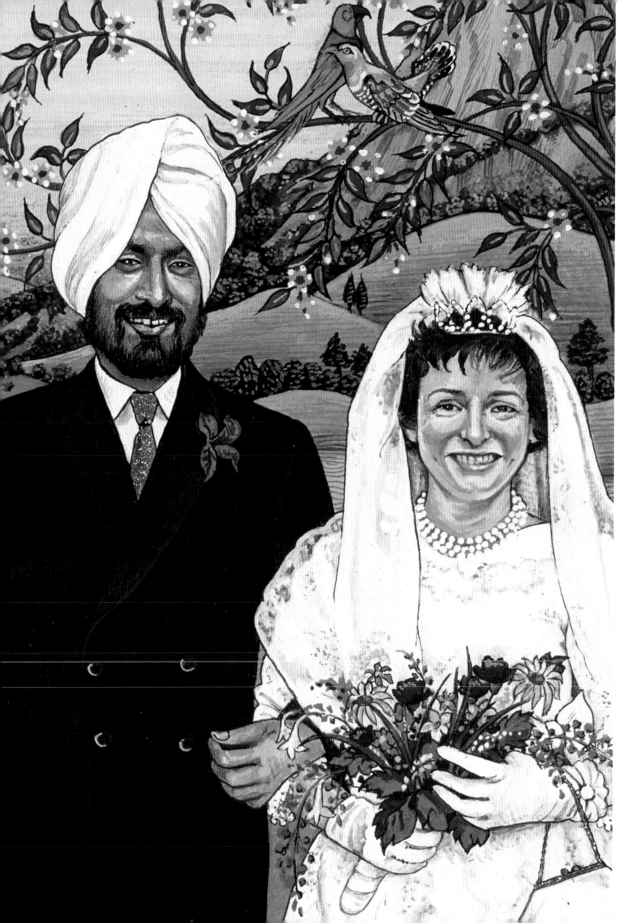

Iqbalnama series

This series of six paintings profiles the life of a modern day Sikh personality, Baron Iqbal Singh, a Glasgow based gentleman who is well known for his patronage of Scottish culture. What is most significant about the series is the fresh dimension it adds to studies of the Sikh Diaspora. The series was commissioned by The Royal Museums Scotland for their permanant collections and one painting in particular is referenced in several official publications on Scottish history, including the Penguin History of Scotland. Hence, they are not just about a Sikh who embraces Scottish culture as his own but about how a Sikh Punjabi has come to be formally recognised as a symbol of contemporary Scottish identity and the collective cultural heritage of Scotland.

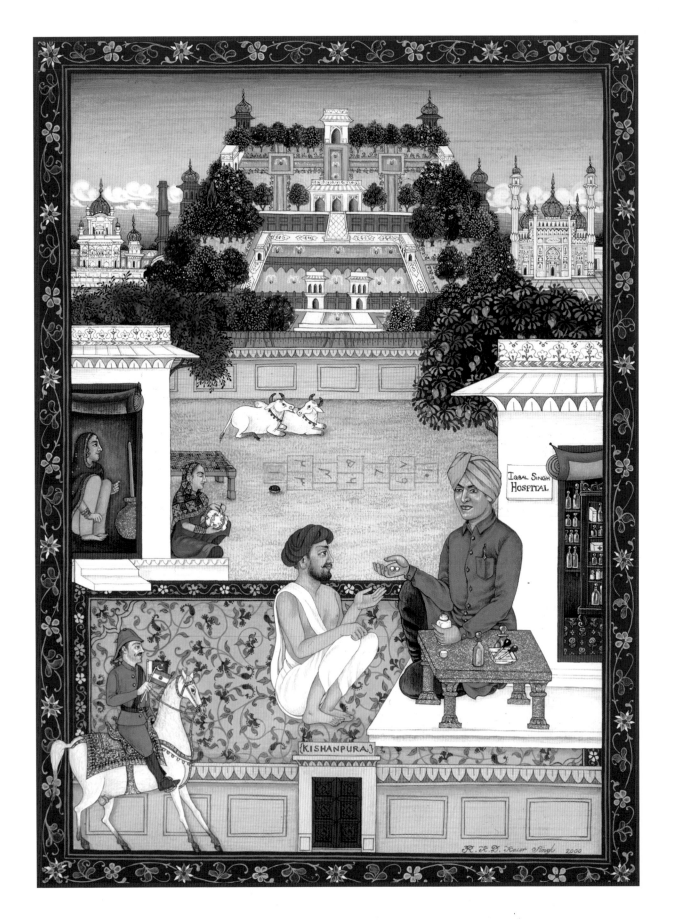

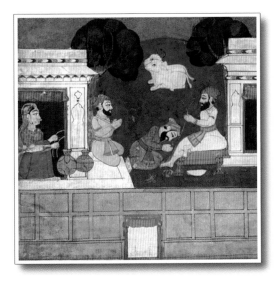

The Laird of Lahore

15.25 x 21.1cm (6 x 8.25in)

Poster, gouache, gold dust on paper

Rabindra KD Kaur Singh, 2000

Acknowledging the sustained media interest that Lord Iqbal Singh has received since moving to Scotland, this painting, like others in the *Iqbalnama* series, takes its title from one of the many press stories about him. Capturing some of Lord Iqbal Singh's memories of childhood and youth, it shows him in the courtyard of his home in the Punjabi village of Kishanpur, near Ludhiana, India. Founded by, and named after his father, the family moved here from the City of Lahore (now in Pakistan) after the partition of India in 1947. Hence, famous landmarks of Lahore are shown beyond the village wall. These include the beautiful Shalimar Gardens (centre), the tomb of the Sikh Maharaja Ranjit Singh (left) and the Golden *Masjid* (right). As a small child, Lord Iqbal Singh spent many hours with his friends playing hopscotch using an empty shoe polish tin for a stone, whilst ladies of the house would churn milk or embroider. The Urdu script on the hopscotch grid and the ornateness of the buildings symbolically reveal the privileged, educated and relatively wealthy background from which Lord Iqbal Singh came. The Parker pen in his shirt pocket, which was 'considered a status symbol at the time' is similarly significant in this respect.

The painting recalls how as a youth of fifteen or sixteen, Lord Iqbal Singh ran a modest 'hospital', dispensing Aspirin, eye drops and brandy, free of charge to sick villagers. This marked the beginning of his early interest in medicine, a field he was to pursue more formally later on. Through the open doorway behind him, we glimpse a cabinet full of medicines and, to its left, shelves lined with the coloured glass bottles that his mother purchased from his uncle in the city and which she collected as ornaments. During the British Raj, Lord Iqbal Singh's grandfather and father served in the army and this strong military connection, is represented by the British General of Punjab who rides horseback. According to Lord Iqbal Singh, the general's regular visits to his family, was a highlight of village life. He arrives on this occasion holding the Indian and Pakistani flags, a reference to the aforementioned partition of India which marked an important turning point in Lord Iqbal Singh's life.

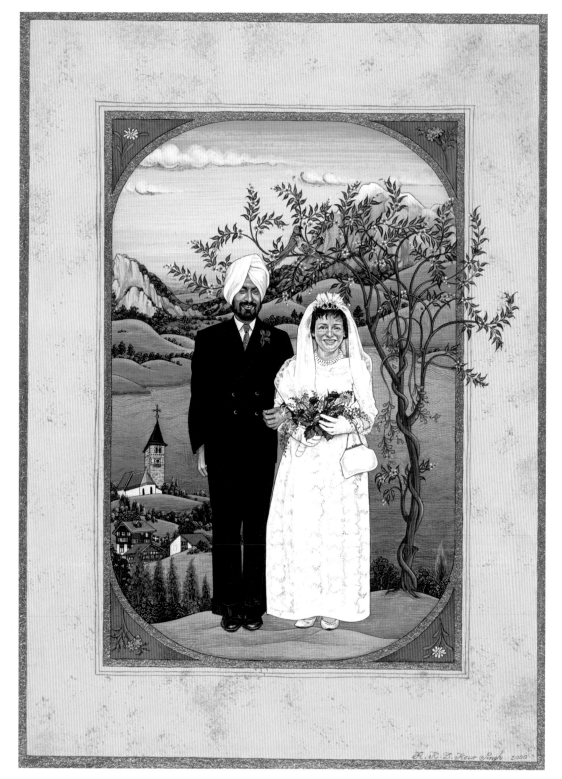

15.25 x 21.1cm (6 x 8.25in)

Poster, gouache, gold dust on mountboard

Rabindra KD Kaur Singh, 2000

This painting depicts Lord Iqbal Singh's marriage to his Swiss-born wife Gertrude. Stylistically, the work draws upon the Kangra and Guler schools of miniature painting, characterised by a palette of subtle colours, which includes a dominance of pastel pink. The oval frame is also characteristic of these schools. The couple stand in formal wedding photo pose against a typical Swiss landscape of snow capped Alps and chalets which incorporates the little church where they married. Several symbolic conventions have been borrowed directly from the traditional Indian miniaturists' treatment of the 'lover' theme. Hence, two birds represent the married couple: the Punjabi parrot and the Swiss cuckoo, which nestle together in a blossoming tree. In addition, the creeper clinging to the tree is a visual allegory for the union of lovers and interdependence of husband and wife. On a universal level the marriage scene represents not just the union of two individuals but the successful merging of two cultures. This is symbolised by the marigold and edelweiss motifs (representing India and Switzerland respectively) that decorate the border.

To the Manor Sporran

15.25 x 21.1cm (6 x 8.25)
Poster, gouache, gold dust on mountboard
Amrit KD Kaur Singh, 2000

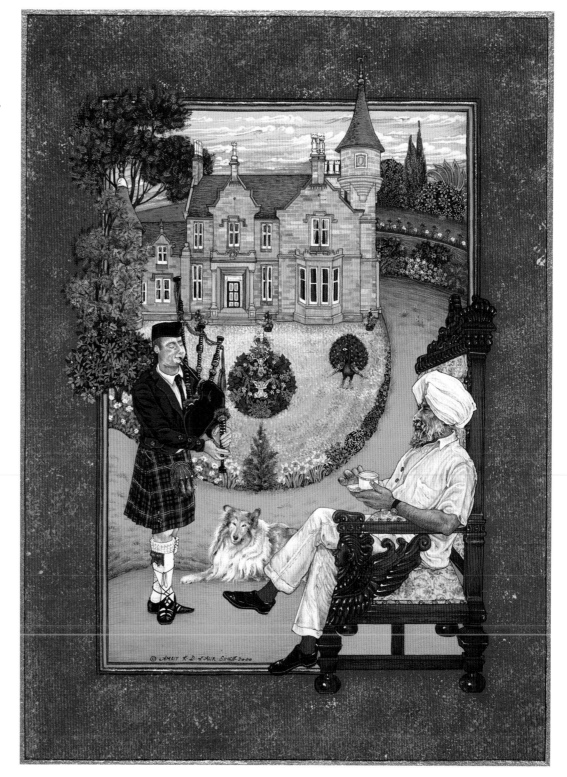

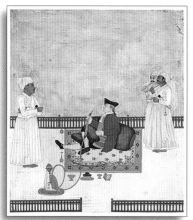

One story to make the headlines, was Lord Iqbal Singh's purchase of a Scottish castle. Here, he is depicted as 'Lord of the Manor' sipping tea to the tune of bagpipes. The scene is reminiscent of a popular genre within Indian miniature painting, particularly that of the 19th century Company Style school which found patronage amongst the new British rulers in India.

This typically showed the British sahib in the lap of luxury, being waited upon by his Indian servants (above). The role reversal depicted in *To the Manor Sporran* presents a light-hearted twist to this traditional theme. In addition, the composition, like another in the *Iqbalnama* series (*All for Burns and Burns for All*), mirrors a press photograph that appeared in a published article - an association which again draws attention to the history of media interest in Lord Iqbal Singh.

Since their introduction to India during the British Raj, the bagpipes have continued to be used in official and private ceremonies and symbolise the historical and ongoing link between Scottish and Sikh heritage and culture. Finally, as an animal typically associated with formal portraits of Indian nobility, Lord Iqbal Singh's much loved dog, Lucky, completes this image of the Scottish Sikh Laird.

All for Burns and Burns for All

15.25 x 21.1cm (6 x 8.25in)

Poster, gouache, gold dust on mountboard

Amrit KD Kaur Singh, 2000

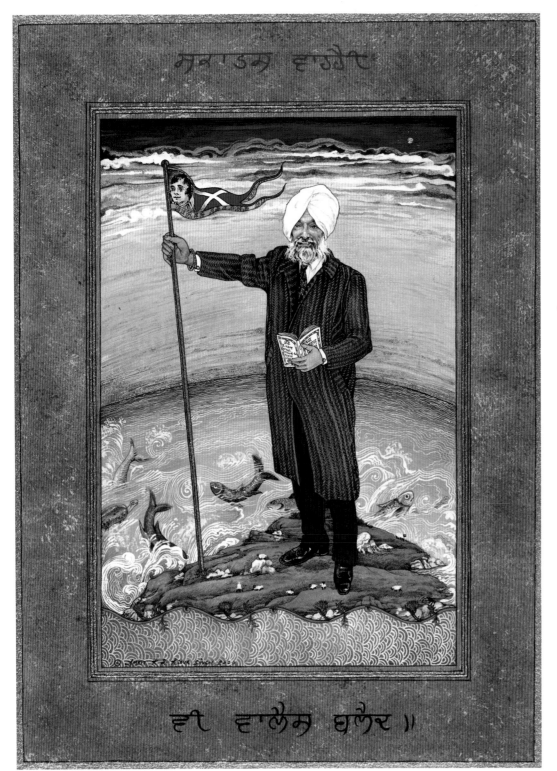

As a tribute to Lord Iqbal Singh's personal admiration for one of Scotland's most celebrated poets, Robert Burns, this image depicts how he has devoted himself to honouring the memory of Burns and to promoting his work. It shows Lord Iqbal Singh on the Outer Hebrides Island (formerly called Vacsay) which he purchased and renamed Burns Island. Significantly, rather than planting a flag which bears his own crest, he is shown planting a Scottish flag which bears the image of Robert Burns.

In addition, the lord holds a copy of the Punjabi translation of Burns' poems, which he specially commissioned as a means of bringing the poet's work to wider audiences. In keeping with the tradition of Indian illustrated manuscripts, some of the verse from one of his most famous poems:- 'Scots Wha Hae Wi Wallace Bled,' is inscribed in the border of the painting. The specific choice of this poem serves to convey both the artists' personal tribute to the Scottish hero William Wallace, who has a parallel in the Sikh historical figure Maharaja Ranjit Singh ('The Lion of Punjab'), and the long-standing cultural and historic relationship between Scotland and Punjab. It also symbolises the comparison that is often made between the Scottish and Sikh character. The lone star, top right of the composition, represents the one which was named after Robert Burns.

Laird Singhs his Tartan's Praises

15.25 x 21.1cm (6 x 8.25in)

Poster, gouache, gold dust on mountboard

Rabindra KD Kaur Singh, 2000

*I*n both composition and style, this portrait of Lord Iqbal Singh is modelled on the conventional Imperial Mughal miniature format (left). It pays tribute to Lord Iqbal Singh's well publicised personal interest in the promotion of Scottish culture and in particular, his commissioning of the first officially registered tartan for the Scottish Asian community, the Singh tartan. In the border, a Punjabi weaver produces this whilst a Scotsman sits opposite him weaving a paisley shawl, with the two lengths of cloth meeting in the centre.

This symbolises the past and ongoing exchange and fusion of Scottish and Punjabi culture. Significantly, the loom on the left is engraved with the thistle emblem of Locharron of Scotland (the company that produced the Singh tartan), whilst the loom on the right bears the arrow symbol of Maharaja Ranjit Singh, the Sikh ruler who introduced the Kashmiri (or Paisley shawl as it was later called) to Scotland. Popular legend has is that Ranjit Singh first exported shawls from Punjab and then sent a number of Punjabi families to train the weavers of Paisley in the art of paisley shawl making. The strong historical links that exist between Punjabi and Scottish culture are further represented by the lion and the marigold (Punjab) and the stag and thistle (Scotland) motifs. Lord Iqbal Singh's warm affection for Scotland is indicated by the Scottish flag which supports his family crest.

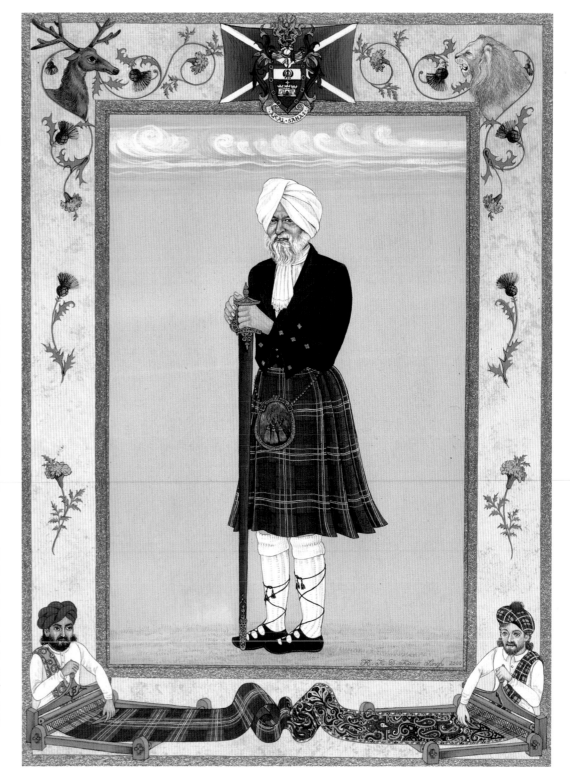

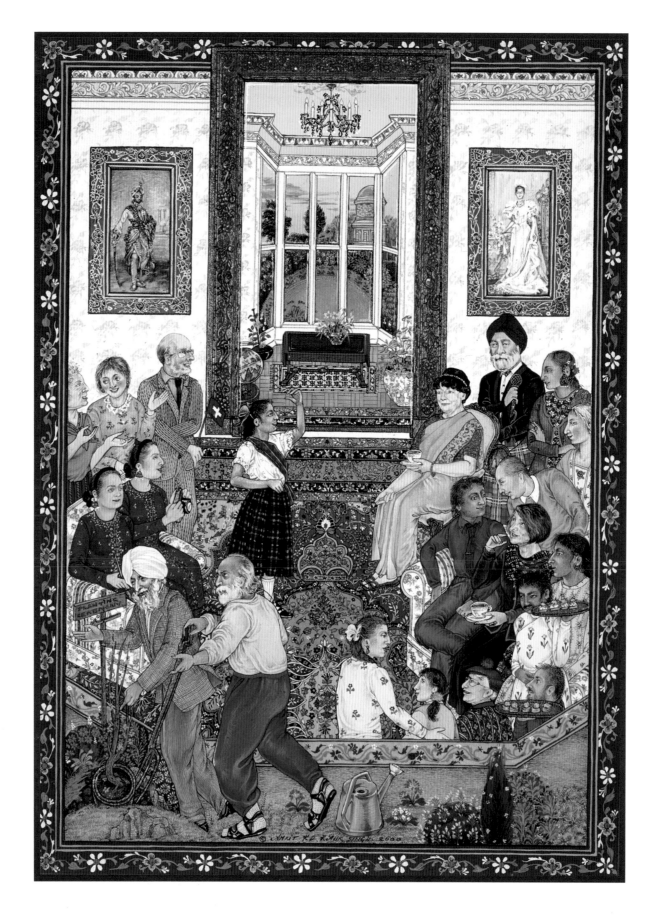

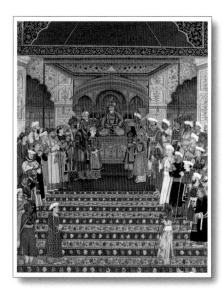

Lesmahagow Durbar

15.25 x 21.1cm (6 x 8.25in)

Poster, gouache, gold dust on mountboard

Amrit KD Kaur Singh, 2000

Adopting the composition and format of the Imperial Mughal miniature *Durbar* or court scenes (above), this painting depicts the gathering of friends and acquaintances at Lord Iqbal Singh's castle home. Among those present, are members of the local Scottish Swiss community who were invited to the castle on the occasion of the formal visit of the Swiss Ambassador to London. The Sikh gentleman who stands (top right) with microphone in hand is a Canadian guest - a writer for the *Toronto Star*, who featured Lord Iqbal Singh in one of his columns. He represents Lord Iqbal Singh's growing global celebrity status as a recognised patron of Scottish heritage and promoter of Scottish Sikh relations. His formal Scottish dress, which includes the Singh tartan kilt, symbolises how Sikhs world-wide have embraced this modern expression of Sikh identity and pride. Just as the traditional miniature painters sometimes included themselves within the scenes they recorded, The Singh Twins are clearly identified here, holding the tools of their profession: a camera and a paint brush. As an appropriate documentation of the history of the *Iqbalnama* series, Mrs Guest, who conceived the idea for the commission, is shown in pensive gesture, watching the festivities. Lady Iqbal Singh provides a key focus within the composition. She sits in a throne-like chair, dressed in a pink silk sari and tiara that lend a refined dignity to the occasion. The traditional entertainer at the Indian Court (the courtesan or nautch girl) is replaced here with a Scottish dancer of Asian descent, representing mutual respect in the meeting of East and West within a multicultural society. Meanwhile, in a scene bottom left, the artists' father is invited by Lord Iqbal Singh to plant a tree in his grounds. Beyond recording a personal memory of the artists' visit to his home, the 'planting ceremony' represents something of a tradition, which Lord Iqbal Singh extends to his visitors as a mark of hospitality and friendship. The imposing gold mirror that forms a central point for the painting's symmetrical composition actually exists at the residence. Its historical importance as an object once owned by Lord Hamilton is alluded to by the reflected view of the Hamilton Monument, a familiar landmark on the outskirts of Glasgow and all that remains of the stately home where the mirror once hung. Left of the mirror is a portrait of Maharaja Dalip Singh who, as the son of the great Sikh Ruler, Ranjit Singh, is a reminder of the long tradition of nobility within Sikh history and symbol of a continuing nostalgia for the glorious era of Sikh rule in Punjab. On the right is a painting of Dalip Singh's daughter, Princess Bamba (later Mrs Sutherland) whom Lord Iqbal Singh recalls as having been privileged to meet. The decorative frames around both portraits copy the patterned border of a stunning Islamic ceramic tile panel that was restored and is now housed by the Royal Museums of Scotland. This decorative motif makes a connection between the museum's history of interest in art forms that were once regarded as belonging to 'other cultures', but which are now valued as an integral part of Scotland's multicultural heritage – and the *Iqbalnama* Series represents just one, but important, facet of this.

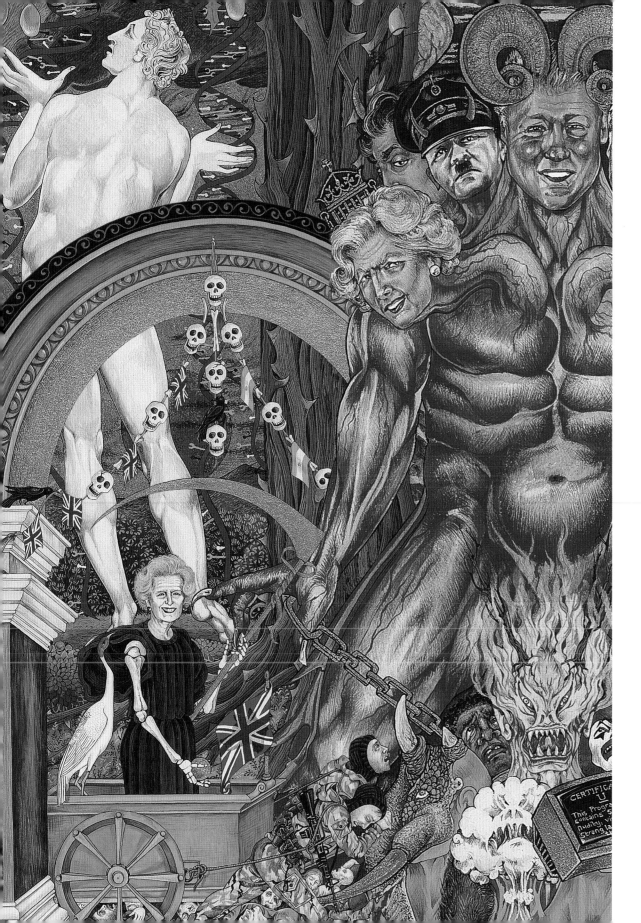

The Hart and Blake Projects

Love Lost and *The Grim Reaper* developed out of a project commissioned by Blackburn Museum and Art Galleries, UK. The artists were invited to study the museum's significant collection of early illustrated European and Eastern manuscripts, know as *The Hart Collection* and to offer a contemporary response. The artists' interest was to explore the aesthetic relationship between manuscripts from different cultures and periods in time - producing new works inspired by particular themes and stylistic characteristics found in the collection. In addition, they created an *Artists' Book,* as a permanent resource for the museum, which recorded their personal analysis, responses and insight into how these historical works related not only to each other and their own work, but aspects of contemporary western art history.

The Beast of Revelation and *Paradise Lost* reinterpret two works by the Victorian symbolist, William Blake. They were commissioned by an established London curator for inclusion in his Cork Street Gallery show *Blake's Heaven: A Tribute Exhibition to William Blake*, in 2001. Having been asked to give a personal response to any aspect of Blake's work, The Singh Twins drew upon his well known biblical representations, *The Great Red Dragon and the Beast from the Sea* (c1805) and *The Temptation and Fall of Eve* (1808). Like many of their other works, these Blake inspired pieces offer a contemporary relevance to an ancient theme. Whilst incorporating some element of the Indian Miniature aesthetic, they deliberately remain faithful to the style of Blake's originals but modify the symbolism and content to present a very direct and vivid comment on what the artists project as their own issues of concern within current scientific debate, politics and society.

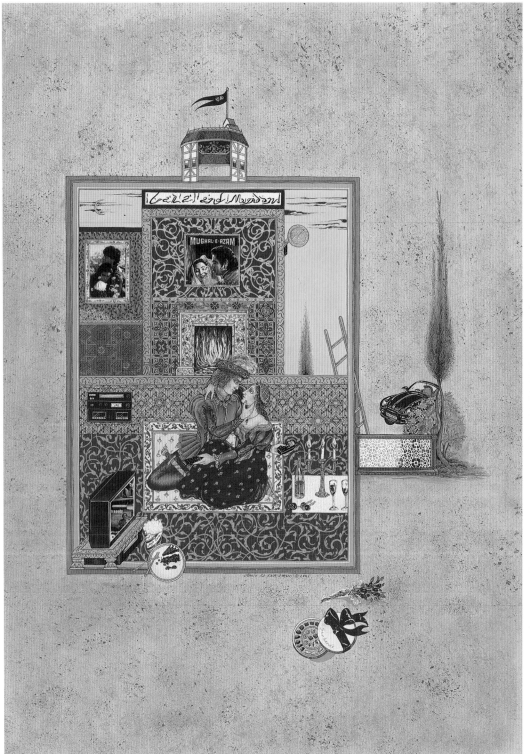

Love Lost

28.6 x 40cm (11.25 x 15.75in)
Poster, gouache, gold dust on mountboard
Amrit KD Kaur Singh, 2001

The format of this painting draws on traditional manuscript depictions of the classic Persian love story *Laila Majnu*. It uses an exploration of the universal theme of true love to highlight the issue of cultural ownership and shared cultural histories, by incorporating imagery relating to Shakespeare's Romeo and Juliet - which some believe, borrowed from the earlier Persian narrative.

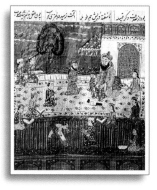

The two star crossed lovers are juxtaposed with an environment in which the individual components collectively transcend cultures and time. The sustained popularity of both the Persian and Shakspearean version of this eternal love story within everyday culture and art is represented by details which signify how the story has been narrated, modified and retold against an ever developing global entertainment media and communications technology.

Other objects within the painting offer a satirical look at how in our modern society the tendency to base relationships on materialistic and individualistic needs, falls short of the kind of selfless, all consuming 'true love', that legends are made of.

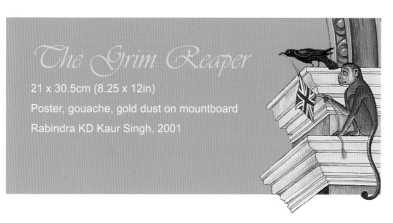

*U*sing former Prime Minister Margaret Thatcher and the context of the Falklands War as an archetype, this symbolic portrait reinterprets the traditional image of the Grim Reaper, as a war mongering politician who not only uses conflict to further personal ambition, but has the arrogance to claim the 'glory' of winning as a personal victory.

The painting suggests that such politicians wave the flag of patriotism whilst the real motive or driving force, is an egocentric greed (symbolised by the crane and monkey) and thirst for material gain and power (represented by the golden orb) - ultimately paid for by the suffering and death of the many thousands of soldiers and innocent victims which the horrors of war claim. Hence, the silhouette of a dog, as the symbol of deceit, is superimposed on the Union Jack. Furthermore, weapon-shaped motifs replace the floral designs that decorate the pillars of the arch in the original 15th century Italian painting of the Grim Reaper (above).

The idea for the painting was sparked by the following rebuke made by Margaret Thatcher to one of her cabinet ministers:

'Michael, have you ever won a war? I have.'

For the artist, this painting emphasises the conceit of someone who would make such a claim when, in fact, nothing could be further than the truth.

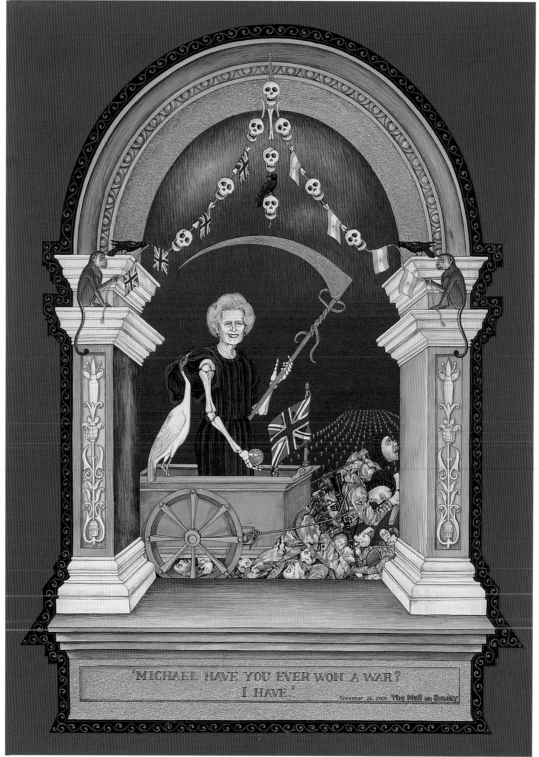

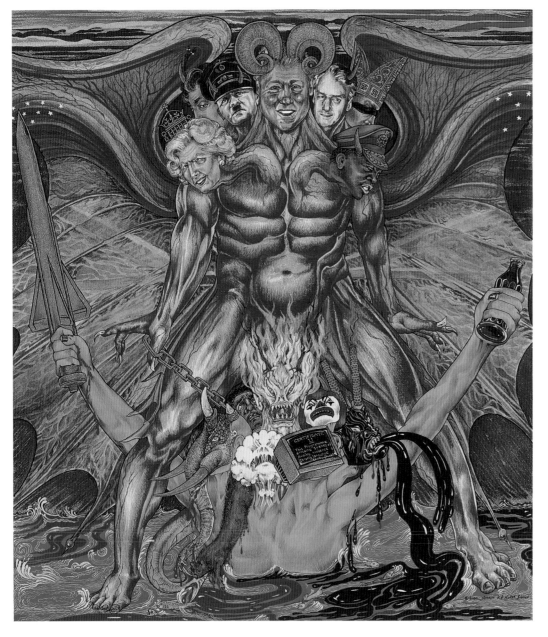

The Beast of Revelation

21 x 19cm (8.5 x 7.5in)
Poster, gouache, gold dust on mountboard
Amrit KD Kaur Singh, 2000

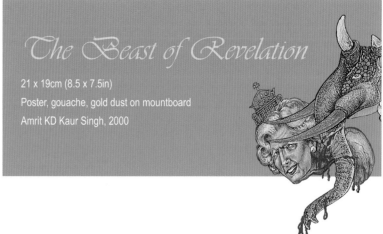

The biblical account of St John's vision of the seven headed red dragon and the seven headed blue beast rising from the sea has been interpreted variously. However, within early Christian tradition it was popularly seen as symbolising the partnership between evil earthly rulers and Satan's servant (or the Antichrist), which would lead to the temporary stronghold of Satan over the world, before his final defeat in the ultimate battle of 'good over evil' at the second coming of Christ. *The Beast of Revelation* presents a universal context for interpreting this specifically Christian theme - transforming these biblical monsters into what, for the artist, constitute the very real 'demons' of our own time. Here, the red dragon becomes the personification of destructive, selfish and corrupt politics - perpetrated on the one hand by a secular world leadership obsessed by personal status and power, and sustained on the other hand, by the failings of an institutionalised religious leadership (the traditional guardians of moral conscience) that is too concerned with self preservation to intervene. Similarly, the blue beast personifies what the artist suggests are the 'partners in crime' of political and social corruption. Namely, excessive economic greed, unfettered technology, environmental exploitation and the manipulative power of the mass media. In this contemporary reinterpretation of Blake's work, Satan's reign on earth is translated in terms of the tangible evils of this world which are ultimately rooted in the symbiotic relationship between political power and economic greed - evils which have manifested themselves throughout history in the horrors of war and the atrocity of slavery; in the gluttony that has made species extinct and laid waste natural environments; and in the moral and spiritual decline of an increasingly individualistic, consumer society controlled by market forces and political agendas.

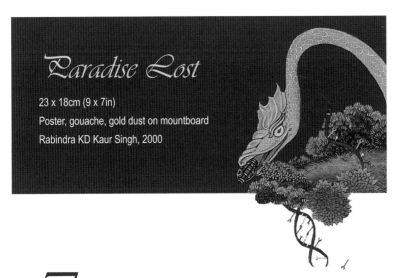

Paradise Lost

23 x 18cm (9 x 7in)

Poster, gouache, gold dust on mountboard

Rabindra KD Kaur Singh, 2000

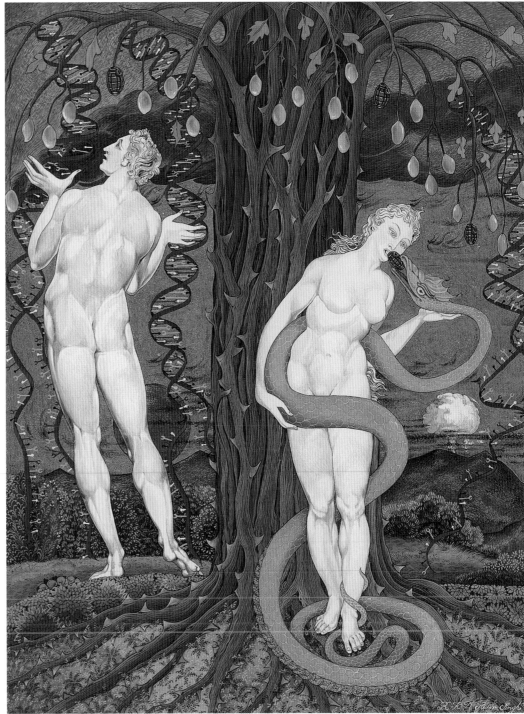

*I*n this painting the biblical account of the temptation of Adam and Eve is reinterpreted in the context of 20/21st century technological and scientific advancements. It questions mankind's seemingly unquenchable thirst for knowledge, and warns of the destructive potential of the misuse of knowledge, when it is void of moral conscience and driven by political and economic greed.

In particular, it addresses the ongoing debates around genetic engineering, symbolised here by the unravelling strands of DNA that hang from the branches of the tree of knowledge. The image offers a counter position to the argument that research into this area can be controlled and that the possible abuse of its application kept in check. Hand grenades replace the traditional fruit of forbidden knowledge. These, together with the atomic mushroom cloud signify the repeated lessons of past human experience where so called 'advancement' in science and technology have inevitably been used by those in power to cause more harm than good - in terms of both human suffering and environmental damage. Money, as the root cause of this manifestation of evil, is symbolised by gold coins lining the serpent's belly. The loss of paradise, therefore, is interpreted not as a theological concept relevant only to the Christian context but as a continuing and universal reality of the here and now.

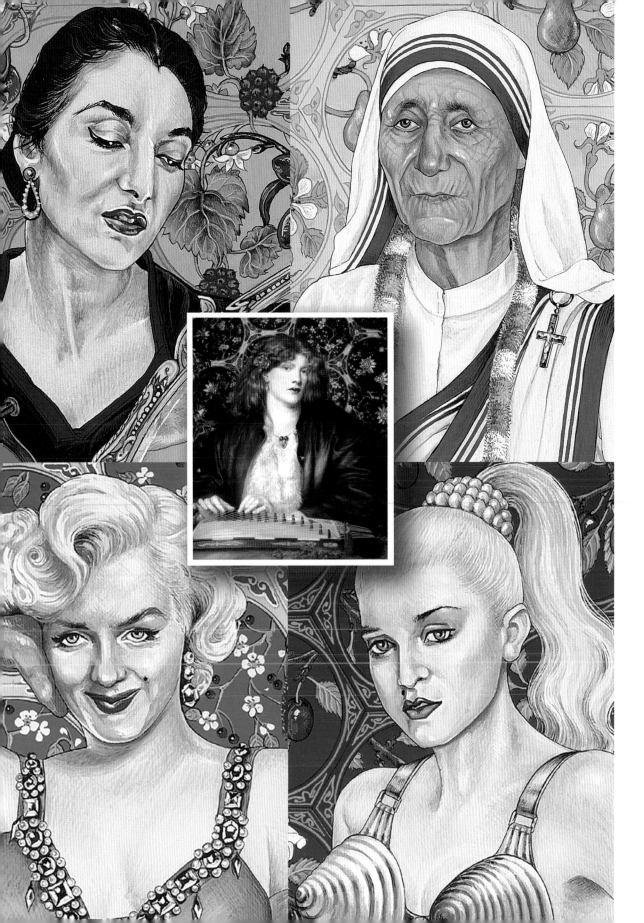

Facets of femininity series

\mathcal{T}his series of works was created by The Singh Twins at the invitation of The Barber Institute of Fine Arts, Birmingham, in a response to its major 2000 exhibition, *The Blue Bower: Rossetti in the 1860's.*

Retaining the format of Rossetti's *The Blue Bower,* the artists reinterpret its symbolism to explore how perceptions of women have changed since then by highlighting the diverse achievements of 20/21st century female icons. From pop stars to princesses, and politicians to 'saints', these works explore different facets of femininity which challenge and update the limited, romanticised and often polarised view of women in Victorian times – women generally characterised by Rossetti and other painters of the Pre-Raphaelite movement as mysterious objects of beauty on the one hand (chaste, dutiful and often vulnerable) and the sensual, femme fatale on the other. Individually and collectively The Singh Twin's portraits reflect the many attributes, which coexist within the complex nature of all that is 'femininity'. The result is a presentation of women that the viewer is invited to love, hate or admire depending on their response to the artists' very personal interpretations. Based largely on observations of media representations, this series of works presents a necessarily stereotypical view of the women depicted, all of whom have influenced contemporary world politics, society and popular culture.

The artists' iniitially intended to represent women from different cultures but during their research, they found the inclusion of non European women within official recordings of female achievement, notably lacking. Consequently, they made a deliberate decision to profile only Western female icons, as a way of exposing the cultural bias of written histories, encouraging debate about why there was such an imbalance of representation and highlighting the whole issue of cultural awareness and worth being evaluated from a predominantly western driven media and popular cultural perspective.

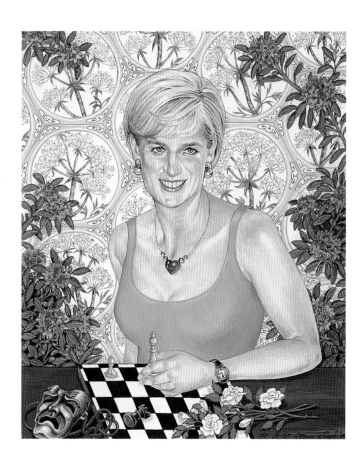

Princess Diana

9.5 x 11.5cm (3.7 x 4.5in)

Poster colour, gouache on mountboard

Rabindra KD Kaur Singh, 2000

It was Princess Diana's fate to play the part of the tragic heroine on the world stage. Exploring this theme, the background is dominated by wild hemlock (associated with death, deceit and ill luck) and the azalea (flower of tragedy) whose white and purple funereal colours aptly reinforce the symbolism of tragedy and sorrow. In front of Diana lies the mask of Melopene, the muse of tragedy in Greek mythology. Like the knot, representing fate, that binds the red ties to the mask, Diana's fate bound her to a woeful destiny. Many saw her marriage into the Royal Family as the cause of much of her misfortune, and the chessboard represents her much-publicised conflict with this Establishment. Appropriately called The Royal Game of Life, chess symbolises the conflict between opposing forces or powers. Diana, who is represented by the white pieces, is seen as the pawn that would not be controlled by the monarchy which is represented by the black castle. In accordance with the rules of chess Diana's pawn, having reached the eighth square of the board, becomes a queen, characterised as 'the free spirit and mover at will' in chess symbolism. Alluding to the fact that, despite having been stripped of her HRH title, Diana was still considered royalty by the public, she holds the queen triumphantly in her hand. The fallen black castle marks Diana's ultimate defeat of the monarchy, whose foundations were rocked not only by her challenges to its traditional ideals and expectations but by the overwhelming public support and sympathy she received following her death. A reference to her wish to be the 'queen of people's hearts' is found in the heart-shaped ruby necklace. The ruby itself is a symbol of both royalty and love. As such, it signifies the more compassionate face which many believed she brought to the monarchy. Just as the use of cornflowers in Rossetti's *The Blue Bower*, related to the name of his model Fanny Cornforth, this portrait incorporates Princess Diana roses. However, taking Rossetti's use of flower symbolism further, their white colour, as the symbol of life after death, also denotes Diana's immortal place in history. Meanwhile, her wristwatch is a reminder of the preciousness of time in this mortal existence.

Mother Teresa

9.5 x 11.5cm (3.7 x 4.5in)

Poster, gouache on mountboard

Rabindra KD Kaur Singh, 2000

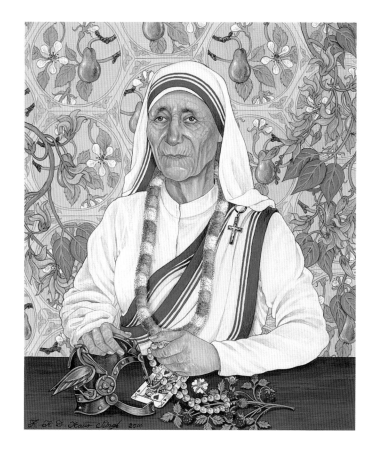

Renowned world-wide for her life long commitment to the poor and sick, Mother Teresa epitomises the qualities of love, protection and self sacrifice which are associated with motherhood, and regarded as intrinsic manifestations of femininity. Aptly, she made her home in India, a country where the status of Mother as giver and sustainer of life, is elevated to that of Goddess. Her 'children' were the people of Calcutta (now called Kolkotta) to whom she offered hope, good health and the love of Christ for mankind - all symbolised by the pear motif decorating the tiles in the background. Like a true hero she chose to devote her life to battling to protect the weak and oppressed. This is symbolised by the warrior's helmet, a significant detail of which is the pelican motif. Known to feed its starving young with its own flesh, this bird is the Christian symbol of self-sacrifice. Drawing again on Christian iconography, the strawberries represent the life of good deeds for which Mother Teresa was highly respected and revered. The rosary, which is associated with a life of prayer or spiritual devotion, represents her elevated status as a saint. The Flame-of-the-Forest flowers provide a similar connotation of sainthood. Their burning orange colour, which was traditionally used by monks in India to dye their clothes, is a symbol of renunciation and sacrifice. As a symbol of love, the King of Hearts playing card in the foreground continues the theme of Mother Teresa as the embodiment of motherly, saintly and heroic love. It also signifies her achievements in the temporal world. Around her neck, Mother Teresa wears a *haar* (garland of honour) made up of the colours of the Indian flag. This expresses the deep respect which this nation held for her and from whom she received the official honour of a State funeral. Finally, this portrait serves as a reminder - against society's tendency to define and evaluate femininity in purely physical terms - of the existence of higher definitions of femininity that transcend the limitations of the mundane. Admired the world over for the strength of character that came from an inner spiritual beauty, Mother Teresa's portrait is a challenge to the kind of 'Look at me', 'Material girl in a material world' role models presented by Geri and Madonna.

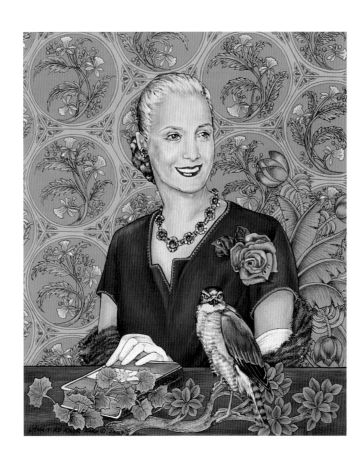

Eva Peron

9.5 x 11.5cm (3.7 x 4.5in)
Poster colour, gouache on mountboard
Amrit KD Kaur Singh, 2000

In deliberately drawing upon one of the most enduring and widespread campaign posters of 20th century Argentine politics, this portrait reflects the immortal status that Eva Peron achieved during her short life. Light greens symbolise the vibrancy of life, and those which dominate the background represent the energy and drive of a woman whose charismatic personality made her an icon of popular Argentine culture and politics. In contrast, the dark greens, which symbolise death, signify her unexpected demise from cancer in the prime of her life. The yellow flowering Margosa tree - native to India and thought to have healing properties that benefit women and children - represents Eva's particular interest in championing women's rights and education. As a universal symbol of learning, the book, whose jacket bears the colour of the Argentine flag, is a more obvious reference to her concerns for mass education. This is further reinforced by the sprig of Indian pennywort (named Brahmi, meaning knowledge) on the book jacket, which, according to sacred Indian texts, has the power to enhance the intellect. Eva's affiliation with the impoverished classes from which she came, and her subsequent work to improve their lot, is represented by a branch from the Banyan - a tree traditionally revered in India as a symbol of sacred protection because of the shade it gives from the sun to both rich and poor alike. The Banana plant, synonymous with plenitude in Indian culture, symbolises the social welfare program that Eva initiated under the Eva Peron Foundation, an institution popular with the Argentine masses but denounced as economically crippling by her wealthier critics. Also criticised by her political opponents was her excessive spending on clothes and her lavish lifestyle, and this is denoted by the style of Eva's attire. However, the mink fur, purple velvet dress and jewels also refer to the jet setting image of self confidence and national pride, which Eva Peron strove to present to the world, at a time when Argentina was struggling to compete for independent and equal acceptance on the playing field of world politics. As the Aztec sun symbol and a universal icon for freedom and victory, the hawk represents both Argentina (the sun emblem being on its National flag) and Eva Peron's successful undermining of British power in Argentina during her political career.

Margaret Thatcher

9.5 x 11.5cm (3.7 x 4.5in)

Poster, gouache on mountboard

Amrit KD Kaur Singh, 2000

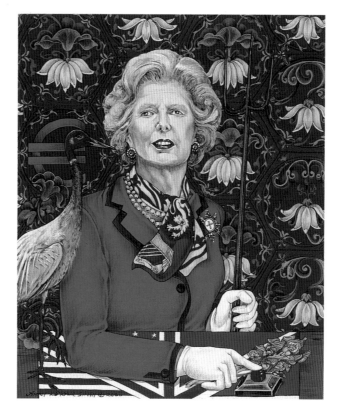

Whilst appearing on the surface to paint a positive image of strong, confident leadership, on closer inspection this depiction of Margaret Thatcher is of a self glorifying, demonic, warmonger. With Satan's trident in hand and finger on the button she personifies, for the artist, the evils of a self-serving obsession for political power. An obvious reference here is to what many believed to have been her deliberate escalation of the Falklands war, through the unlawful and unprovoked sinking of the *Belgrano*, as a means of bolstering her political career. The poison ivy motif and purple background enhance the sinister overtones of this characterisation of Thatcher as the ultimate 'femme fatale' of politics, whose seemingly contrived image as the soft spoken, lipsticked blond masked a ruthless Iron Lady. Associated with regal status, the colour purple also, together with the brooch, Royal Standard scarf and trident (as an attribute of Britannia also) denotes what some regarded as Thatcher's imperialistic outlook and dictatorial style of government. Symbolising a United Europe, the ecu sign in the background alludes to the part that her stubbornness on the issue of British sovereignty would play in her eventual downfall. The fused Union Jack/Stars and Stripes represents the close relationship which Britain and America developed during the Reagan years, and what some felt to be Thatcher's over willingness to follow the American lead. Through this interplay of different symbols, a polarity of positions regarding British sovereignty is presented with a view to exposing the double standards hypocrisy of Thatcher's policy on Europe. The pristine tailored blue suit, so characteristic of Thatcher's wardrobe, symbolises the squeaky clean, public face of politics. In contrast, the white-gloved hands, whilst appearing to complete the image of wholesomeness and decency, are not what they seem - just as the public face of politics is rarely what it seems, as one of them half conceals a stem of deadly, poisonous monkshood. This points to what the artist sees as the workings of global politics: in particular, the cover up of underhanded, dirty dealings, which characterises the abuse of political power. In Indian thought the lotus (which flowers spectacularly above water whilst being rooted in muddy earth below) is likened to the selfless or godly person who works for the good of others in the world, untainted by the vices of material existence. The downward facing lotuses that dominate the background tile pattern reverse the logic of this analogy, portraying Thatcher as an extreme egomaniac, whose thirst for worldly power is viewed as a destructive force. The crane provides a similar analogy, as a bird that spends most of its time with its head in the water fishing, with no concern for what is happening around it. These two symbols also reflect the individualistic 'every man for himself', 'go get ' philosophy of the Thatcher government, with its undermining of traditional community and family values through, amongst other things, its policies on individual poll tax, the unions, privatisation and free enterprise.

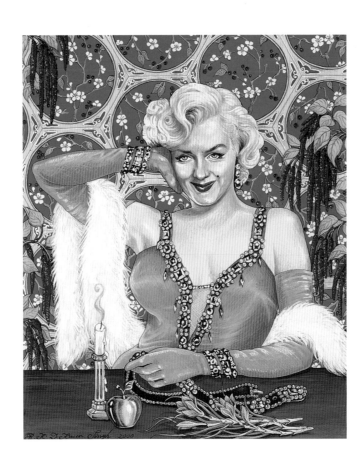

Marilyn Monroe

9.5 x 11.5cm (3.7 x 4.5in)

Poster, gouache on mountboard

Rabindra KD Kaur Singh, 2002

The bright blue and yellow background of this portrait evokes the 'glorious Technicolor' of the 50's Hollywood musical, a genre in which the stunningly beautiful and glamorous 'love Goddess' reigned supreme. Epitomising this particular representation of femininity, Marilyn Monroe is paralleled with the ancient Greek Goddess of love and beauty, Aphrodite. Placed before her, is the golden apple that was awarded to Aphrodite by Paris, who judged her to be the most beautiful of all Greek Goddesses. As a further testament to her captivating beauty, Marilyn holds a belt that makes reference to the magic girdle possessed by Aphrodite which was 'endowed with the power of enslaving the hearts of Gods and men alike'. Draped in diamonds and pearls, Marilyn's association with the goddess is made complete because, as legend has it, when Aphrodite was born, Horae adorned her with precious jewels. For many, Marilyn is the embodiment of grace and beauty. To denote this, cherry blossoms, the Japanese symbol of youth and beauty, dominate the decorative tiled background whilst, the colour saffron, described as the 'perfection of beauty', is represented by the crocuses whose dried stamens yield the pigment. The candle, which has been snuffed out before it has time to burn, serves as a reminder of the tragedy of Marilyn's death at the height of her youth and beauty. Ironically, it is through her death that Marilyn, like so many other figures from popular culture who have died prematurely, achieved an immortality befitting her status as a 20th century Goddess. This status is symbolised by the fabulous, everlasting Amaranthus flowers that hang behind her. Translated as 'love lies bleeding', the blood red Amaranthus also allude to Marilyn's unhappy life-long search for an unconditional, loving relationship and her unfulfilled desire for a child.

Maria Callas

9.5 x 11.5cm (3.7 x 4.5in)

Poster, gouache on mountboard

Amrit KD Kaur Singh, 2002

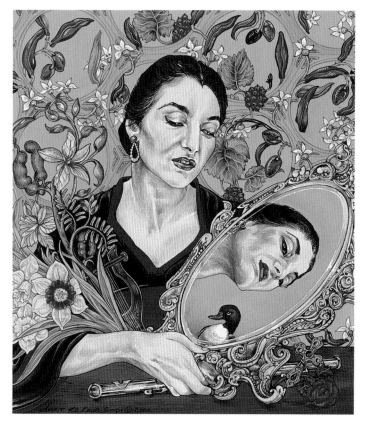

The sense of natural lighting and combination of pale blues, aqua green and yellow in this work evoke the Mediterranean climate, which together with the flowering olive branches in the background decoration, symbolise the deep attachment that Maria Callas (though American by birth) had for her Greek roots. The interjection of vivid reds in her dress and the specific choice of floral details, symbolise the notoriously passionate and fiery temperament of this great prima donna. At the same time, the red of the mulberries takes on an altogether different meaning, where the three colour stages of this ripening fruit (from white to red to black) symbolically correspond to the three stages of human existence (childhood, youth and old age). The particular use of un-ripened mulberries here points to the death of Callas at the relatively young age of fifty-four. The tragic loss of one of the world's greatest opera singers is similarly symbolised in the jewel encrusted cross and single red rose, the two objects that were placed in her coffin. As the Greek symbol of misfortune in love, the mulberries also provide an appropriate reference to Callas's very public and ill-fated affair with the Greek multi-millionaire Onasis. The flute, regarded as the definitive imitator of the human voice, is an obvious reference to Callas's career as a singer. However, as an instrument also equated with anguish and extremes of emotion, it also denotes the tortured and volatile personality of the universal prima donna stereotype. As an attribute of the Sirens of Greek mythology who beguiled sailors with their singing, the lyre represents the captivating nature of Callas's voice, whilst the pink and yellow flowering Tamarind branch stemming from the lyre, signifies the extraordinary quality of her talent. An association is made here with the legendary Tansen who is hailed as the greatest classical vocalist in India's history. The leaves of the Tamarind tree under which Tansen is buried, have been ingested by generations of singers throughout India in the belief that they have voice enhancing properties. The mirror represents the well documented inner conflict and obsession that Callas had with her physical appearance. The reflected image in particular points to her sense of self-disgust and the ugly duckling syndrome of her childhood years which, despite her becoming regarded as one of the world's most beautiful women, stayed with her throughout her adult life. Callas's emotional insecurity was regarded by some as the root cause of her problematic relationships, which were often characterised by self destructive, narcissistic tendencies. Hence the bouquet of daffodils (narcissi), which are the Greek and Chinese symbols of introspection, self-love and death.

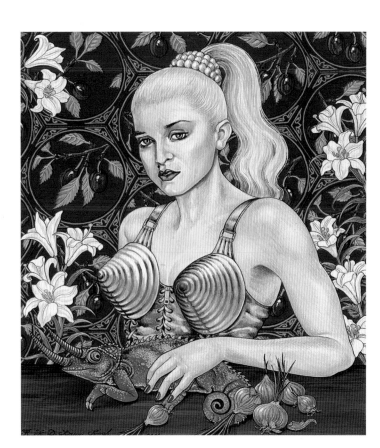

Madonna

9.5 x 11.5cm (3.7 x 4.5in)
Poster, gouache on mountboard
Rabindra KD Kaur Singh, 2002

Like the chameleon she holds, Madonna appears to be a creature of many guises, changing her colours continually throughout her career to project many diverse images of femininity. This portrait depicts what remains probably one of her most controversial and enduring images. Wearing the famous Gaultier corset that accentuates a curvaceous and highly toned body, Madonna projects a sexuality that combines both masculine and feminine attributes. It is a vision of femininity that is far removed from the more traditional ideal exemplified by the Monroe type, where sensuality goes hand in hand with charm, grace and a degree of coy innocence. For some, Madonna's style of femininity is a strong positive image of self-confidence, empowering women to flaunt their sexuality on their own terms and for themselves, rather than conforming to the expectations of a traditionally male dominated society. For others, such a graphic, 'in your face' display of sexuality is regarded as crude and obscene, insulting and degrading to women and a threat to the status quo. A direct parallel may be made here with Rossetti's *The Blue Bower* which was as controversial in its day and condemned by the Victorian establishment as vulgar and improper because of what was considered to be its overtly sensual and sexually suggestive content. Madonna's undoubtedly strong personality, and her reputation as a woman who has not only survived but taken full control of her career in a male dominated business, is represented by both the use of bold red and scarlet, and the plum motif (the Chinese symbol of strength and endurance). Also significant is the ponytail hairstyle. Worn by Madonna in real life, it serves as a reference to the wild horse which, as a symbol of the untamed spirit, provides a further analogy for Madonna's character. The onion, whose core is concealed by many layers, offers an analogy for a pop icon whose true personality has perhaps remained hidden from public view, similarly concealed beneath the many outer faces she has presented over the years. Finally, the inclusion of Madonna lilies, mimics Rossetti's use of plant symbolism to identify the name of his model in the *The Blue Bower*.

Geri Halliwell

9.5 x 11.5cm (3.7 x 4.5in)

Poster, gouache on mountboard

Amrit KD Kaur Singh, 2002

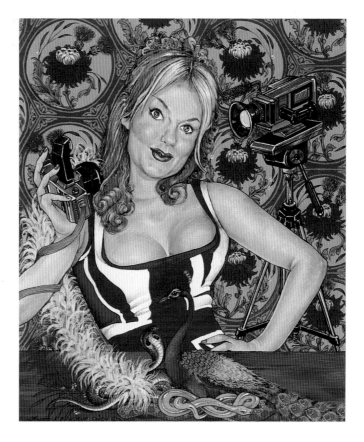

In true Ginger Spice fashion, this portrait of Geri Halliwell exploiting her femininity to maximise her media appeal, epitomises the unashamed *in your face* flirtatiousness with which she is popularly associated and which became synonymous with the brand of 90's style 'girl power' promoted by the Spice Girls. Wearing the boa and headline-making dress that became her trademark, Geri poses against a background of clashing luminous colour and bold pattern, reminiscent of the psychedelic 60's and 70's, an era which the Spice Girls revived through their eclectic tastes in fashion. The chrysanthemums, which are showy and brash, allude to Geri's media image, whilst the common name of those depicted, the Firecracker, invites the viewer to take this analogy further. The suggestion being that, just as firecrackers make a lot of noise with little to show for it, so too has Geri's career - often characterised by her critics as being all image with no actual talent. The thistles continue this symbolic parallel between flowers and the way in which Halliwell is perceived because, as one of Britain's most widespread and hardy flowers, they represent her thirst for celebrity and her determination to survive in the highly competitive world of media and pop. Her many efforts to reinvent her public image have led critics to dub Geri the 'would-be Madonna'. This is represented by the snakes, which, as creatures that renew themselves by shedding old skins for new, are a symbol of resurrection and renewal. The peacock of vanity and self-pride, alludes to the criticism of Geri as a self centred, extrovert, attention seeker. It is no accident, therefore, that she is also shown aiming the cameras at herself. Like the portraits of Princess Diana and Madonna, the thin green leaves of flowering ginger on the table and in the background tile pattern serve to identify the sitter.

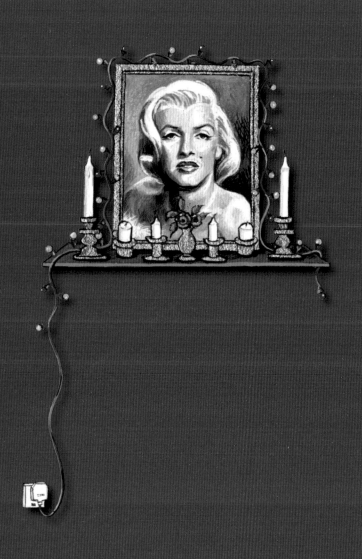

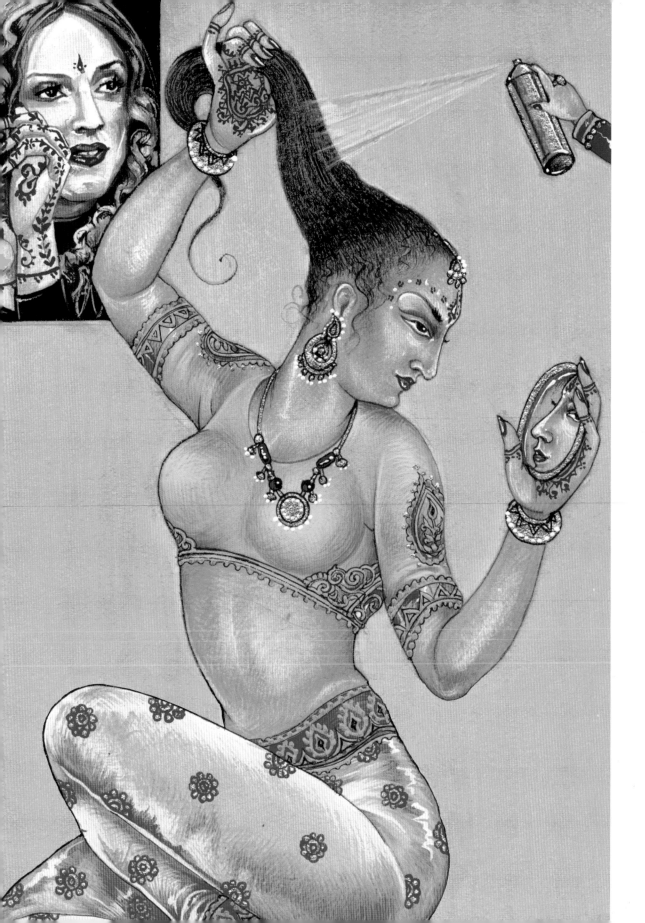

The Art of Loving series

\mathcal{R}agamalas, or 'Garlands of Music' are a tradition of miniature painting originating in 17th century India which sought to give visual expression to the many moods and emotions created by the system of different melodies *(ragas)* found within classical Indian music. These paintings drew upon the rich symbolic imagery contained in poetic verses written a millennium ago, thus bringing together poetry, art and music in a unique relationship. Each *raga* was personified, or represented in human form, and the feeling it evoked depicted as distinct modes of human emotion and experience, in which the relationship between two lovers was a favourite theme. The mood and character of each *raga* was also associated with specific colours, the seasons and the time of day - all of which became important compositional considerations for creating the desired atmosphere and sentiment. In a context where classical Indian music was regarded as a tangible vehicle for spiritual experience and communication, the material relationships depicted in *Ragamala* paintings were often analogies for the spiritual relationship between the soul and God.

The Art of Loving is a series of works, which not only continue the *Ragamala* tradition but reinterpret it within a secular, contemporary context. Seeking to highlight the connection between poetry, visual art and music, as well as the parallels between East and West, each work adopts the title of a song from the canon of modern western popular music whose theme, melody and lyrics reflect the key sentiments and mood expressed by the painting.

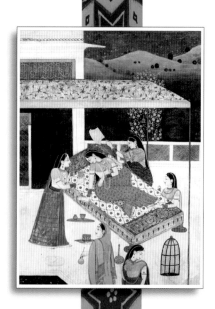

Some Like it Hot
(Burning Desire)

23.5 x 23.5cm (9.3 x 9.3in)
Poster, gouache, gold dust on mountboard
Rabindra KD Kaur Singh, 2003

Some Like it Hot offers a contemporary interpretation of ragas *Bavari* and *Kamodi* - two melodies which express the emotion of burning passion and desire. Traditionally, these are 'usually visualised as a girl with her hands joined over her head (*karkata hasta*)', whilst an attendant tries to offer relief from the unbearable heat of the summer season (symbolising the girl's mood) either by fanning, or applying cooling henna to her feet (inset).

This painting was inspired, however, by the alternative representation of a specific 17th century, Rajput, miniature titled *Longing* from the Fogg Art Museum, Harvard University Collection. Transporting the heroine into a 21st century setting it reinterprets the age old sentiment of the original *raga* within the modern context of the movie fan who is 'in love' with her screen idol. Hence, the focus of the work is a young woman reclining on her bed, her head thrown back in blissful, romantic contemplation as she gazes up at a poster of Mel Gibson, the object of her desire. The depth of her infatuation is emphasised by his image on the bedside dresser, as well as on the front cover of the film magazine, which drops from her hand as her mind wanders to thoughts of romance.

Continuing the symbolic use of colour in traditional *Ragamala* paintings, reds and oranges, representing love and passion, dominate the palette. Similarly, the burning desire that consumes the young woman is likened to the scorching heat of an 'Indian summer' which is conveyed through the glowing saffron and warm orange of the background with its cloudless, hazy sky. To further help convey the mood, an electric fan and ice cubes have replaced the old symbols of the hand fan and henna.

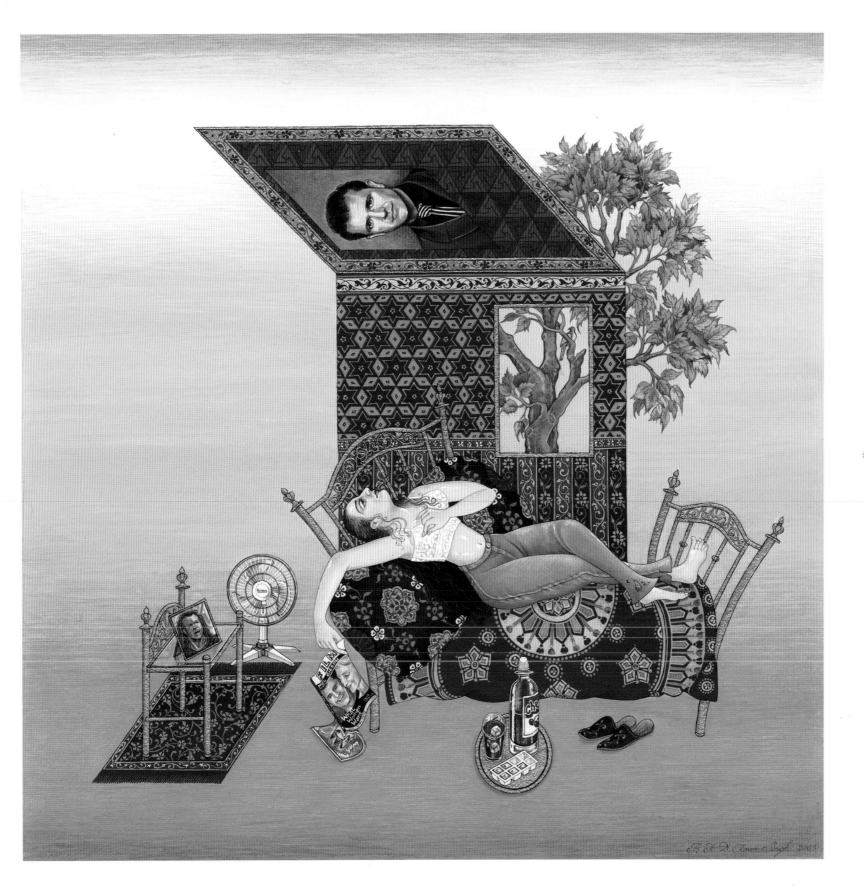

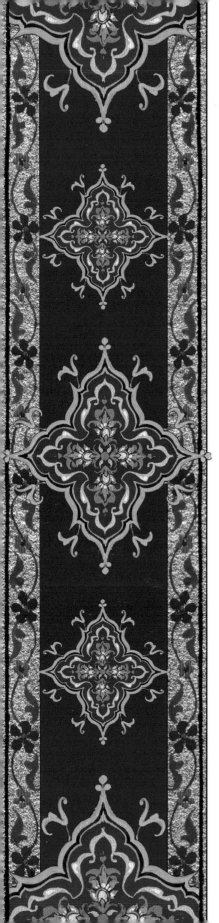

Raining In My Heart
(Longing)

25 x 23.5cm (9.8 x 9.3in)
Poster, gouache, gold dust on mountboard
Rabindra KD Kaur Singh, 2003

As with the painting *Some Like it Hot* this work represents *Raga Bavari*, the melody which expresses the emotion of passionate desire and longing for union with one's beloved. Again, the contemporary context chosen in this case is the fan-movie star relationship. However, in contrast to *Some Like it Hot* (which seeks to capture the blissful mood of one whose passion is totally fulfilled - at least, in their imagination), *Raining in My Heart* deals with the unhappiness of someone who longs for a love which he knows is unattainable. Hence, a young man is shown pining away in his bedroom, which has become a shrine dedicated to his 'love', Marilyn Monroe. Supported by a large cushion he holds his head in despair as he gazes down at several of her photographs. Like that of the young woman in *Some Like it Hot* his posture is copied from an old miniature painting. The composition also draws inspiration from traditional depictions of *Raga Dhanasari* which often show a woman contemplating a portrait of her lover. As someone who has locked himself away from the outside world, the oversized scale of his figure in relation to the room creates an appropriate sense of claustrophobia and imprisonment. Symbolically, this denotes a heart and mind trapped in a state of sadness from which there is no release. In addition to the use of predominately sombre, earthy colours the man's sorrowful inner emotion is portrayed poetically through the dark, gloomy clouds and pouring rain.

A particular miniature (inset, top right) inspired the specific layout of details within the composition but the overall division of space follows a common convention of the Indian miniature tradition - with roughly two thirds of the area being apportioned to the main architectural structure and one third to the landscape outside. In a wider context both this painting and *Some Like it Hot* highlight the modern world's obsession with the icons and romantic themes projected by the film and television industry, and questions the role these play in shaping, not only peoples' expectations of their ideal lover, but the concept of love itself.

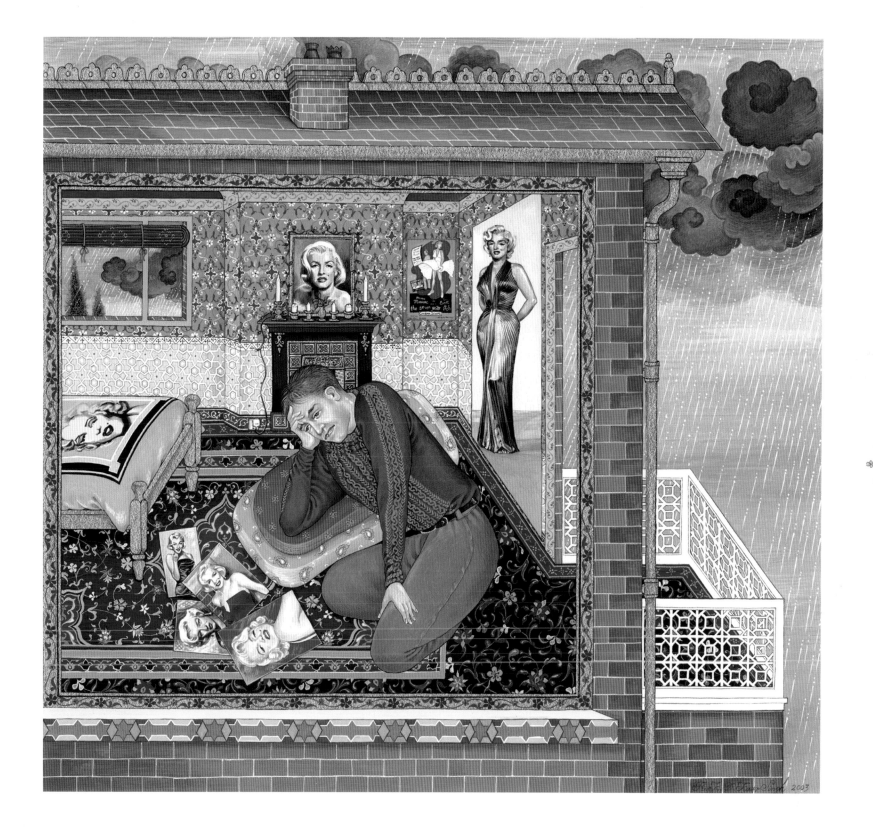

Star on a TV Show
(Public Relations)

29.5 x 36cm (11.6 x 14.2in)

Poster, gouache, gold dust on mountboard

Amrit KD Kaur Singh, 2003

*R*agas *Pancham* and *Malkaus* are melodies which express the joy of union - a theme that is depicted in *Ragamala* paintings as the secret rendezvous between two lovers enjoying the pleasure of each other's company. The lovers are often shown walking or riding horseback in the forest, or, else, in amorous embrace in the seclusion of romantic surroundings such as a grove, walled garden or palace terrace. Seen as an analogy for the reuniting of the soul with its Divine origin, the union of lovers acquired a spiritual dimension.

In contrast, *Star on a TV Show* explores how, in today's world of global communication and entertainment, something that is considered sacred, intimate and private in traditional Indian art and philosophy, has been trivialised and turned into a public affair. It reflects a society in which the rich and famous, hounded by the paparazzi, are regarded as public property, and where the public relations machine is courted by those willing to exploit their personal relationships in the pursuit of higher financial gain and notoriety.

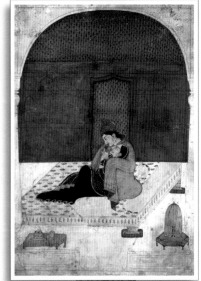

The line between real-life and fantasy relationships is blurred in the world of movies, reality TV and docu-soaps. The painting, therefore, questions the global obsession with fame, and the kind of role models that are being created for a society in which meaningful and long lasting relationships are breaking down, and people seek emotional consolation and live out their desires through the lives of celebrities and fictional characters.

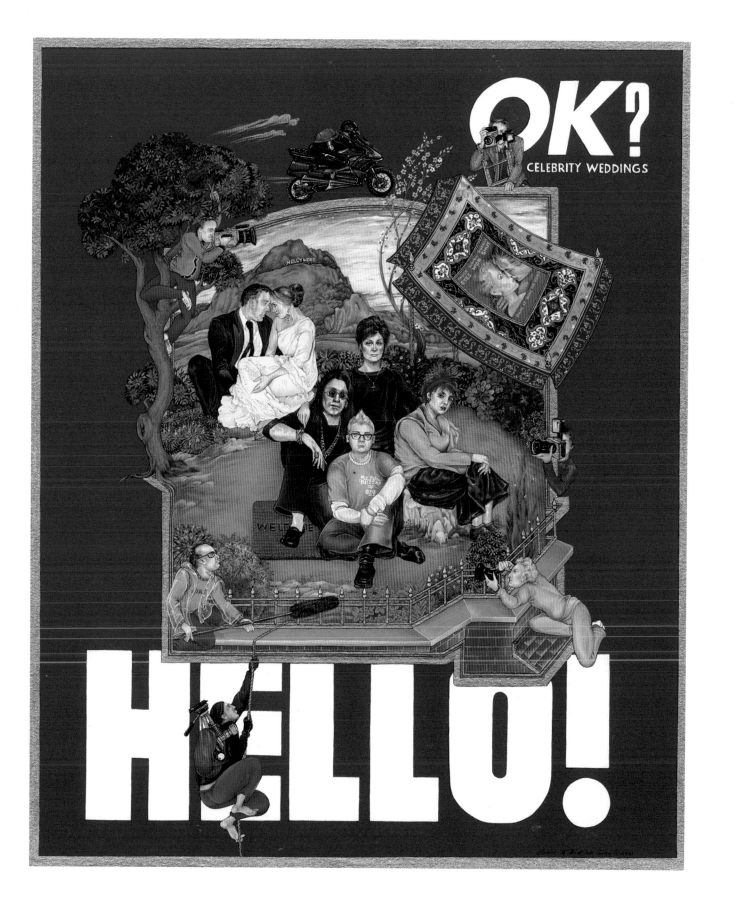

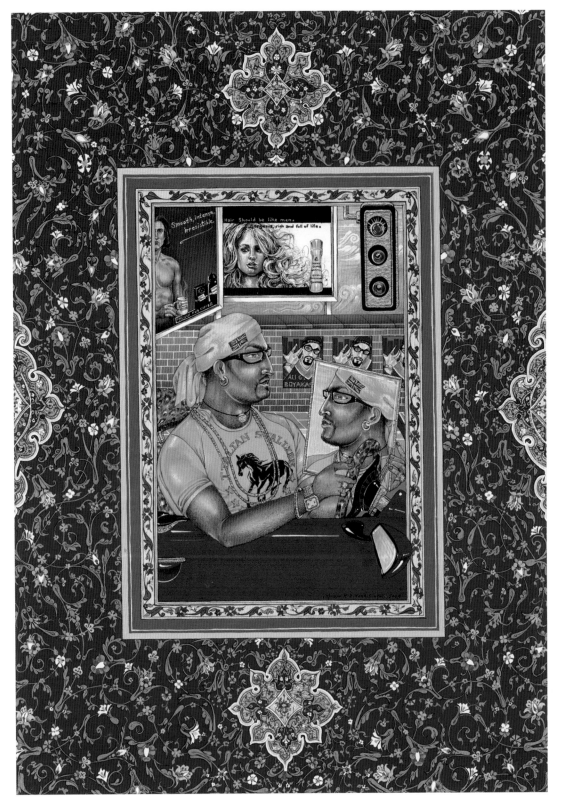

I Feel Pretty
(God's Gift)

21.5 x 30cm (8.5 x 11.8in)

Poster, gouache, gold dust on mountboard

Amrit KD Kaur Singh, 2003

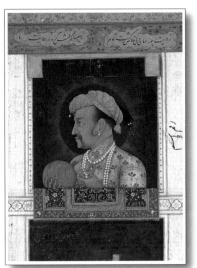

Turning the traditional artistic representation of the musical *ragas* on its head, this work moves away from the lofty ideals of a selfless, all consuming love for and devotion to the 'other', to create a new 'I love me' *raga* for the modern world - one that reflects an image conscious society increasingly driven by consumerism and the cult of individuality. Presenting a satirical scenario of egotistic love, it depicts an urban stereotype of the young man with 'attitude' who enacts a life defined by trends in advertising and pop culture - totally blind to how others perceive him and too absorbed in himself and his fabricated world to value relationships in the 'real world'. His actions, posture and various trappings of material status betray the emotions and mood of a character whose conceit and self assurance is alien to the underlying spiritual dimension of 'shared'' human relationships explored by the traditional *ragamala*. Rather than following a typical *ragamala* composition, the format more appropriately draws on a familiar convention adopted for the royal portrait in Indian miniatures - a genre which generally projected the ego of the ruler and his glorified (often self made) larger than life, status.

Funky Weekend
(Absent Lover)

23 x 33cm (9 x 13in)
Poster, gouache, gold dust on mountboard
Amrit KD Kaur Singh, 2003

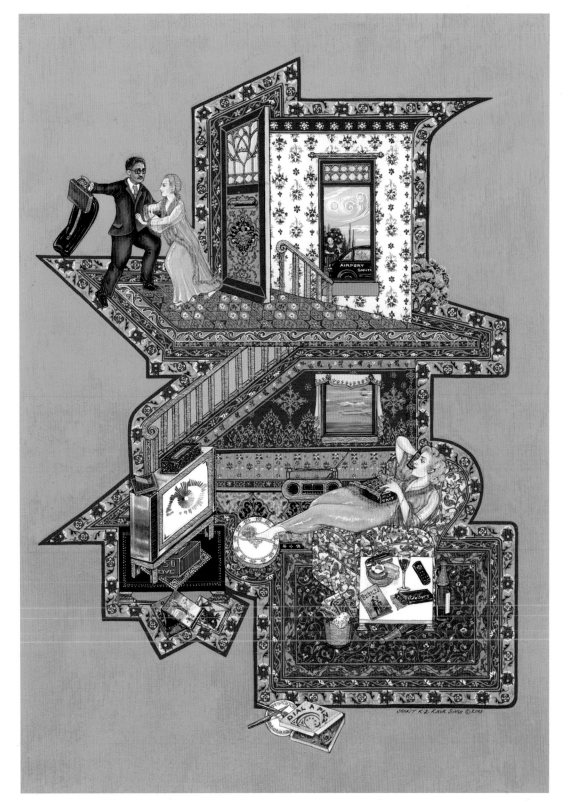

Ragas *Dhanasari* and *Bhairavi* evoke the emotions of loss and longing. They are visualised by the absent lover theme in ragamala paintings - a scenario in which the level of love, devotion and commitment between a man and woman was perceived to be so great as to make the pain of separation too much to bear. This was typically depicted as the young woman seated or reclining on a terrace pining for her beloved, contemplating, and sometimes painting, his portrait to pass the long days of loneliness. Other times, she gazes at the distant horizon waiting for him to return from home (inset above). Often these depictions took a narrative form, representing, for example, the protracted farewell before separation. But in all cases the women are shown suitably distressed and inconsolable. Like other *ragamala* works, specific seasons and colours were used to emphasise the mood of the theme - such as dark skies of billowing clouds to symbolise a heavy heart and times of trouble. This theme would have been particularly poignant within the historical Indian context - where the fate and status of women in society was inextricably tied to the men on whom they inevitably depended for protection and material support. However, *Funky Weekend* reinterprets these *ragas* within the more 'realistic context of a modern relationship that sees separation and solitude as a welcome release from emotional attachment and commitment to the humdrum norm of married life. Here the wife revels in the pleasures of her own company, escaping into a dream world of books and films, surrounded by her home comforts. Her body language and the unabashed, warm colours reflect the overall mood of the scene as she relaxes unperturbed by her husband's absence.

To All the Girls I've Loved Before (Playboy)

26.5 x 31.5cm (10.4 x 12.4 in)
Poster, gouache, gold dust on mountboard
Rabindra KD Kaur Singh, 2003

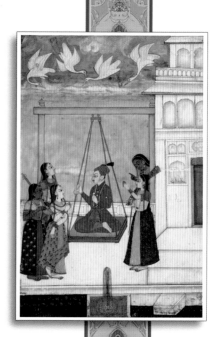

This image offers a light-hearted reinterpretation of *Raga Hindola* - a melody that expresses youthful, carefree love. The personified form of this raga is described as a man who 'is wily and clever, courting many women without being true to any one'. Within a contemporary context, the artist has likened this type of man to that of the playboy.

In traditional representations the man is shown sitting on a *hindol* (literally,'swing') which is being pushed by his pretty female companions (inset right). The swing itself is a symbol of 'frolicsome delight' because of its association with India's Spring Festival, *Holi* - traditionally a time of joy and fun, when 'the thoughts of young men and women turn to love'. In the artist's interpretation the ancient Indian swing has been replaced with a modern day equivalent, and further symbols of a carefree life have been added to the composition- namely, the swimming pool, cocktails and cigars. The inclusion of these objects also helps to create a summer holiday atmosphere (i.e. a time of enjoyment within the western context). As such, the season of summer, conveyed through the clear blue skies and blossoming trees, replaces that of spring. And, as young beauties attend to their playboy's every need, a bluebird, symbolising the 'fickleness of [his] short lived affection' for them, flies overhead.

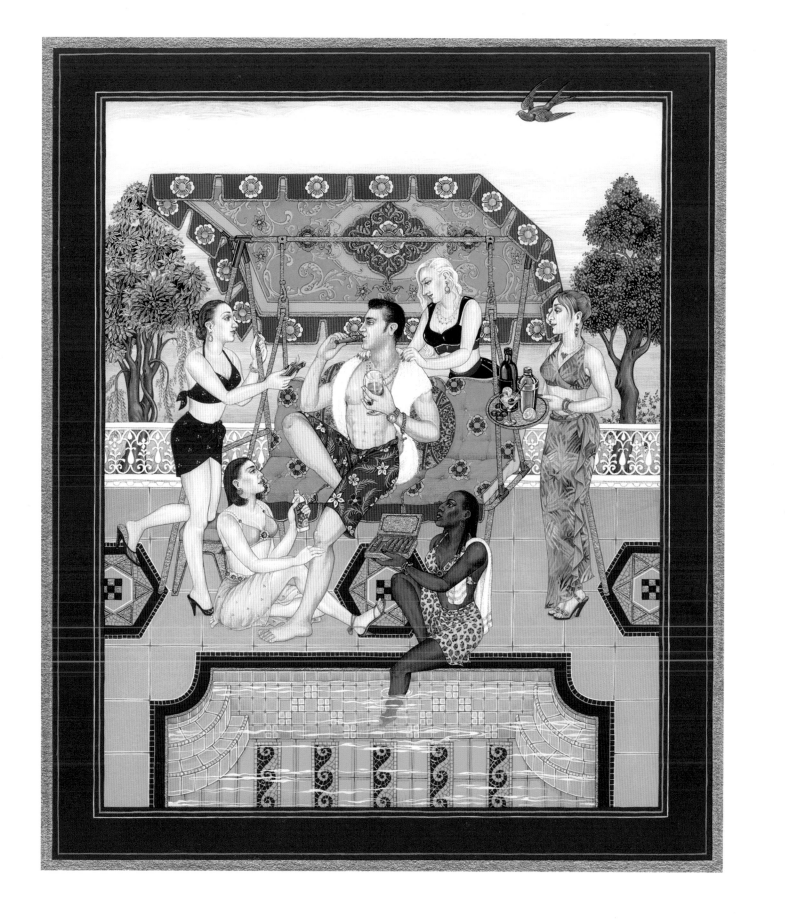

Solitude (Absent Lover)

29 x 35cm (11.4 x 13.8in)
Poster, gouache, gold dust on mountboard
Rabindra KD Kaur Singh, 2003

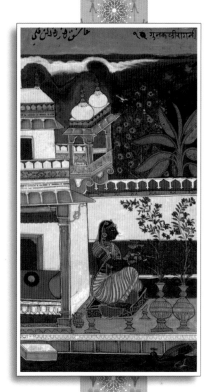

Ragas *Gandhari, Gunakali* and *Gunjari* are all melodies that express the sorrow and anxiety of a woman whose husband (or lover) is away, or has deserted her. A common traditional representation of this theme shows a woman preparing a garland of flowers (inset top right) in hopeful longing of her lover's return. Another convention shows a maidservant consoling her forlorn mistress who fears that her lover is being unfaithful. The melancholic mood conveyed by these *ragas* is visually associated with stormy weather conditions (inset bottom right).

In this contemporary version, the sad melody is depicted as a woman sitting alone at a dining table set for a romantic dinner. On the mantelpiece a calendar, clock and telephone symbolise her anxious waiting, the passing of time and her futile expectation of his return. The burnt-out candles and the changing colour of the sky also represent the passing of time, as night turns to day. Rather than preparing a garland of flowers for her lover the woman in this scene plucks the petals one by one as she questions in despair, whether *he loves her*, or *loves her not*.

The women depicted in traditional *ragamala* paintings often address their laments to the peacock (symbol of the absent lover). However, in a context removed from the Indian landscape, here the actual bird is transformed into a decorative wall hanging.

The bleakness of the mood expressed in *Solitude* is reflected by the cold and windy weather of Winter. Continuing the poetic character of *ragamala* imagery, the bending trees mirror the lowered head of the woman, in sympathy with her sorrow. Similarly, in the hearth, the smouldering embers signal the end of a love affair that once burned bright.

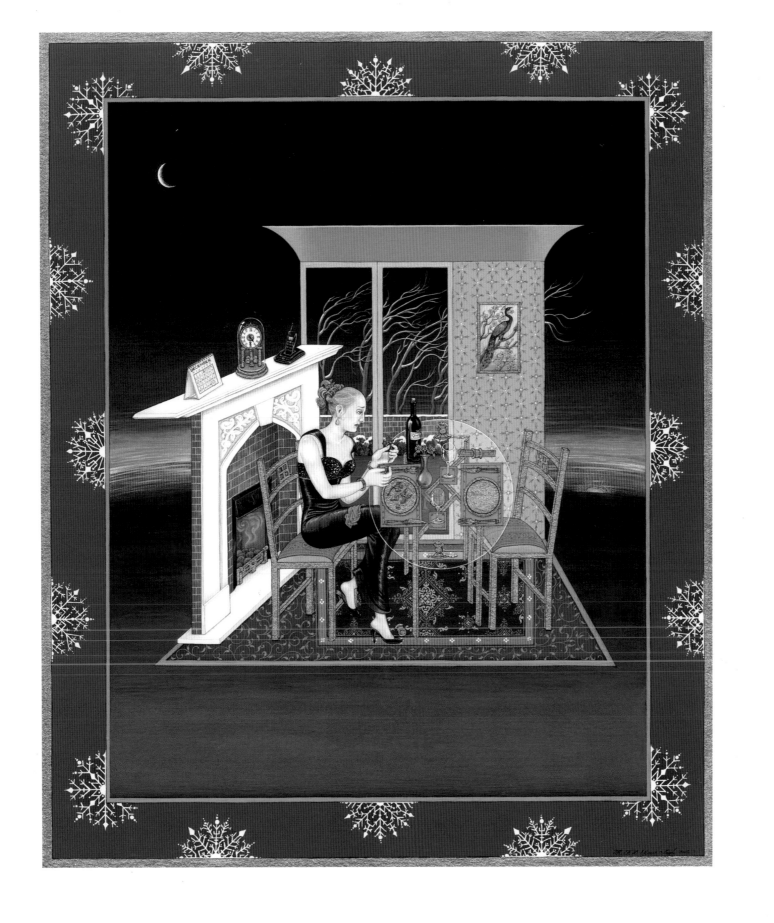

Steppin' Out with My Baby
(My Donna)

23.5 x 25.5cm (9.3 x 10in)

Poster, gouache, gold dust on mountboard

Amrit KD Kaur Singh, 2003

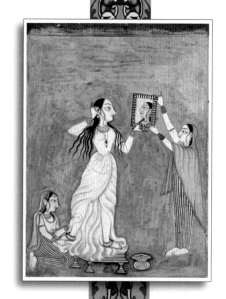

This work draws on the traditional representation of *Ragas Bilawal* and *Telangi* which express the excitement of young love through the image of the sweetheart who adorns herself in joyful anticipation of her lover's arrival (inset right). Again, bringing the historical depictions of *ragas* into a modern context, the young lover in *Steppin' Out With My Baby* is shown as a woman of our multicultural world, preparing herself in ways that appear to cross over cultural boundaries - adopting a 'mix and match' of accessories and beauty treatments that combine traditional Indian with more contemporary, Western practices. But, as certain details within the composition suggest, the issue of cultural ownership is ambiguous in a global society where ideals of fashion, beauty and popular culture are predominantly defined by Western role models, and where 'the ethnic' achieves acceptance and credibility, it seems, only after it has been given the stamp of Western approval, or else, modified to fit in with Western notions of the 'Exotic'. So, *mendhi* and *bindia* (the traditional symbols of marriage) are repackaged as 'body art' and 'fashion tattoos'. Stripped of their ancient ritual and cultural significance they become just another fashion statement and one of many 'Asian flavour' commodities (from stage musicals to paisley embroidered jeans and hand bags) that cater for current trends in Western consumerism. The saffron background symbolises the mood of joy, whilst the fluorescent, contrasting colours of the main scene reflect common Western perceptions and stereotyping of Asian aesthetics and taste as characteristically 'Bollywood,' 'glitz' and 'kitsch'. The parrot in flight (symbolising the God of love in Indian mythology) represents the carefree spirit and soaring heart of the lover.

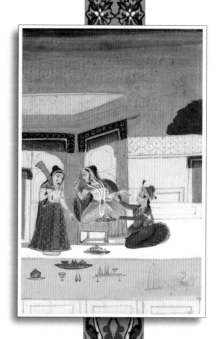

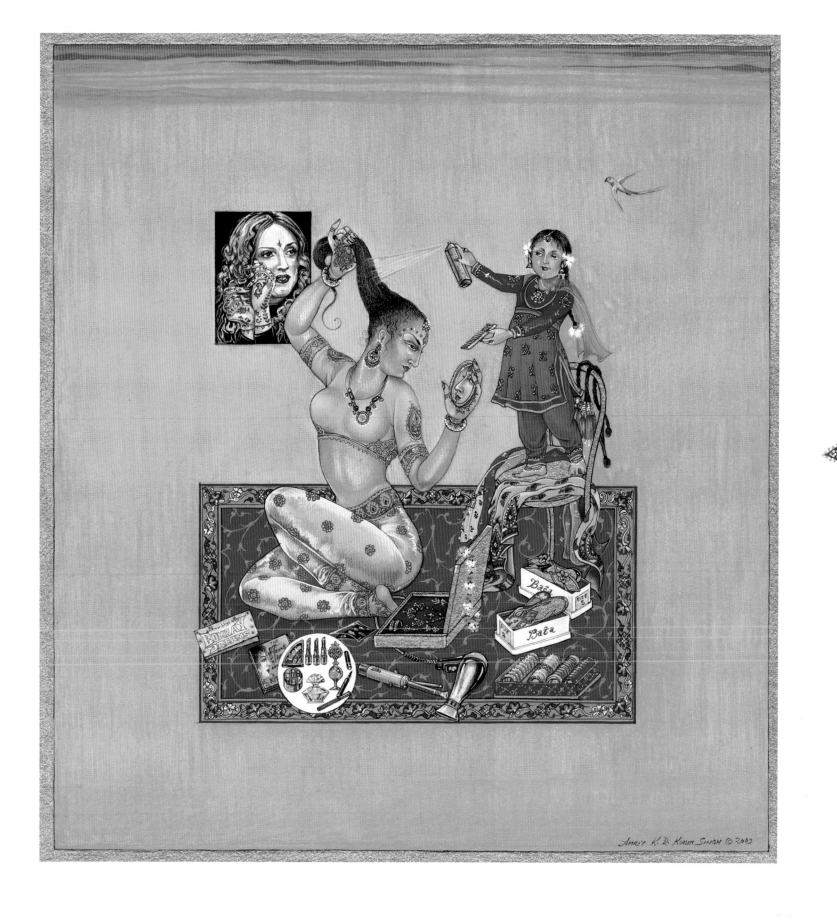

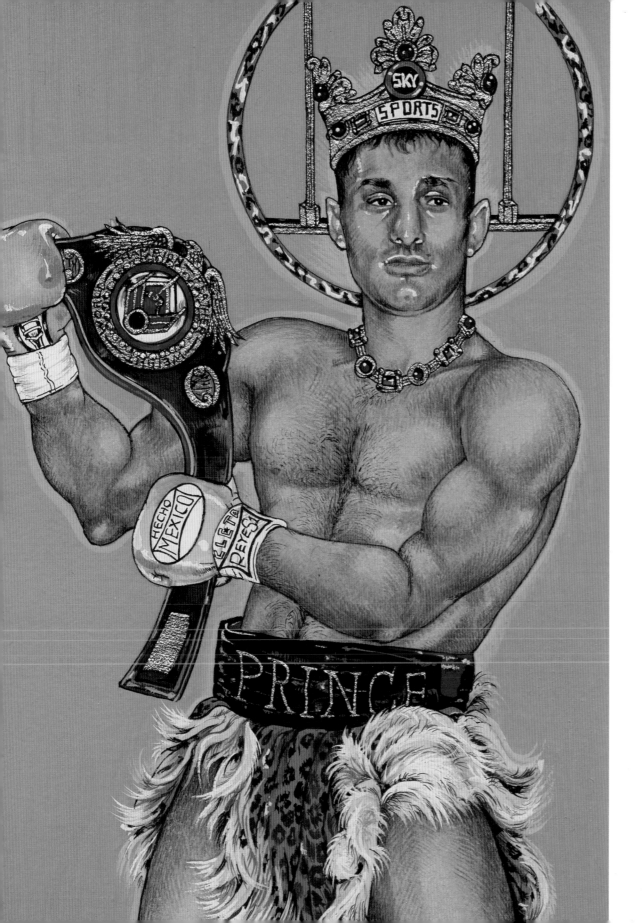

Sportlight series

\mathscr{P}roduced during The Singh Twins' official appointment as artists in residence for the 2002 Commonwealth Games, *Sportlight* explores perceptions and representations of sport in today's world. Sports figures and specific sports are presented in symbolic images that take a light hearted and sometimes satirical look at how commercialisation and the mass media have transformed sport into a tool for product promotion, and increasingly blurred the boundaries between the world of sport, fashion, media and celebrity.

The initial concept behind the series was to create a platform for introducing wider audiences to the traditional Indian Miniature art form through a subject that would have mass appeal as part of established popular culture interest. In a broader context, *Sportlight* projects the artists' ongoing aims to assert the value of traditional and non European aesthetics as a legitimate form of expression within contemporary art practice. As such, each painting reinterprets identifiable examples of 18th and 19th century miniatures housed in private and public collections world-wide, in particular the Victoria and Albert Museum, London.

The Killing Game

34 x 36cm (13.4x 14.2in)

Poster, gouache, gold dust on mountboard

Amrit KD Kaur Singh, 2002

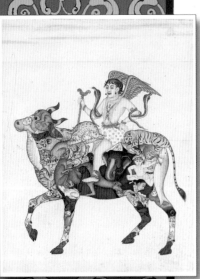

This painting presents an allegorical interpretation of a common theme in Indian Miniature painting, the royal boar hunt. The relationship between hunter, steed and prey, is likened to that of the commercial world riding on the back of the media and destroying the Olympian ideals of true sportsmanship, founded on international goodwill and friendship. It mirrors the composition of the Indian miniature that inspired it (top left), except for a few minor changes in detail, such as the hypodermic syringe which replaces the arrow that strikes the fatal blow to the boar. As a recognisable symbol of drug abuse this detail highlights the detrimental consequences of sports advertising, and symbolises how extreme commercialism has affected the character of the sportsman image. It's a scenario which has witnessed competitors and judges alike resorting to dishonest and illegal means - such as performance enhancing drugs, match fixing, fowling and vote rigging - because of the huge stakes involved and the finacial rewards to be gained. Playing on the popular adage that hunting is the 'sport of kings', it is the logos and products of the rulers of consumerism that make up the figure of the rider. The global expanse of their 'empire' is symbolised by the dollar, euro and sterling signs that grow as tufts of grass on the hunting ground.

As an underlying theme the image also raises questions about boundaries of sponsorship and the appropriateness of product and company endorsement by sports personalities and institutions - endorsements which appears to contradict the popular perception and image of sport as promoting healthy living, the pursuit of excellence, mental and physical discipline and the ethics of fair play. These issues not only question the kind of role models that sporting figures provide for modern society, but the way in which sport is open to abuse and misuse as a result of the loophole it provides companies seeking to circumvent the ban on direct advertising of harmful products.

In composition, *The Killing Game* draws on the 'composite image' convention that is found in several schools of painting within the miniature tradition (inset, bottom left). The technique involved creating fanciful and mythological creatures from different animals and human figures. However, the artist's reinterpretation of the boar hunt theme develops the convention further by applying it to inanimate objects and visual symbols which acquire a significance and meaning in their own right.

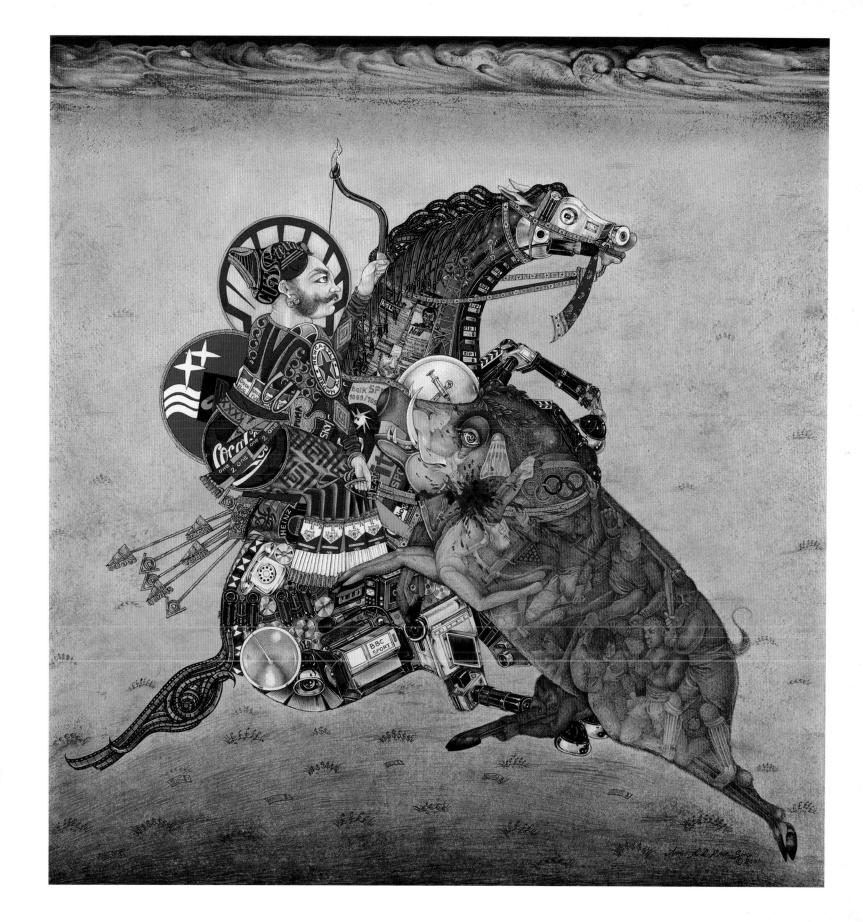

The Greatest

38 x 53cm (15 x 21in)
Poster colour, gouache, gold dust on mountboard
Rabindra KD Kaur Singh, 2002

*K*nown as 'The King' this portrait of boxer Muhammad Ali is painted accordingly in the conventional style used for depicting royalty within the Mughal School of the Indian miniature tradition. In particular it has been inspired by two very similar allegorical portraits of the Mughal Emperor Jahangir (r.1605 - 1627). One is reproduced here (inset, left) and the other, titled *Emperor Jahangir Triumphing Over Poverty,* is housed at the Los Angeles County Museum of Art. *The Greatest* combines features from each whilst at the same time remaining faithful to the general composition of both, in terms of poses and the placement of figures and objects. However, the symbols used in the originals have either been modified slightly or replaced completely by alternatives that are more appropriate and relevant in expressing something of the life, personality and achievements of Ali. In terms of the latter this portrait is not so much a tribute to Ali's boxing achievements as the World Heavyweight Champion, but more a tribute to how he used the platform this provided, to become the 'peoples' champion' in fighting political and social injustice. Thus taking his fights beyond sports onto the world stage'. His fights in the boxing ring became a metaphor for, not only his personal fight for respect and freedom from 'slavery', but also for the equal rights of Black people everywhere who, because of the history of slavery, continued to suffer poverty, injustice and racism at the hands of the 'white man'.

Hence, with broken shackles hanging from his wrists and lying at his feet, Ali is depicted standing on top of the world, which rests on the canvas of a boxing ring. The continent of Africa is significantly prominent as a representation of the race he identifies with, and for whose equality he fights. From this 'platform' he defiantly attacks the symbols of American political and social injustice, prejudice and racism which are impaled on a spear. This includes the severed, hooded head of a member of the Ku Klux Klan and a golden eagle which clutches the Stars and Stripes, along with an emblem of the star sign Virgo (a symbol of discrimination). Like Jahangir, Ali's weapon is the bow and arrow. Traditionally a symbol of war and power, the bow provides a suitable weapon for Ali both on a literal and metaphoric level and has, therefore, been adopted wholesale from the original miniature. However, Ali's 'arrows' take on a different form to those used by the Mughal emperor. Transformed into fountain pens, these have become a symbolic representation of the weapon with which he fights his 'enemies' - namely, his outspoken words and poetic writings. When Ali refused to fight in the Vietnam War on religious grounds, he was stripped of his world title and suffered unjust imprisonment, depriving him of his best fighting years at the peak of his career. In short, he gave up everything for the sake of his religious beliefs as a Muslim. This lack of importance that Ali ultimately gave to a sport in which he excelled, is reflected by the minute size of the boxing ring, which is almost lost in the composition.

Supporting the boxing ring is the beast of burden, a camel. As a symbol of humility and the obedient servant this points to Ali's belief that his 'job' is to 'work for God' and spread the message of the Black Muslim faith as a 'servant of that message'. The camel stands on an island of rock which alludes to the firm foundations, i.e. strength of conviction and integrity, on which Ali's character is built, and which have given him the courage to stand up for what he believes in. The island also symbolises that, as a sporting legend, Ali stands alone in a category of his own. Ali quotes Allah as 'the number one reason for [his] success'. In this respect he, just like Jahangir, is shown being aided by two cherubs from the heavens above. However, whilst Jahangir's

helpers are white, one of Ali's is portrayed as Black. The latter provides Ali with his 'arrows'. Notably, two of these form the shape of an 'X', a reference to the boxer's close association with Malcolm X, who introduced him to the Black Muslim faith. Meanwhile, the white cherub showers Ali with red roses. Representing truth, Allah and the blood of the Prophet Mohammed in Islamic symbolism, these similarly point to the source from which Ali gained the strength to meet life's challenges both inside and outside the ring. On the ground beneath the shower of roses is a cockerel. This serves as a reference to Ali's conversion to Islam, which he once described as 'being like a sudden awakening from darkness into light at the sound of the cock's crow'. On a lighter note the inclusion of a butterfly and a bee allude to one of Ali's most famous sayings. Furthermore, these insects appropriately reflect the boxer's private and public faces - i.e. the peace loving, quietly spoken, gentle man on the one hand and the no-nonsense, hard hitting, sharp-witted boaster on the other.

Around the border of the painting are inscribed a selection of the boxer's quotes. These provided particular inspiration for the focus of the portrait and offer a key to interpreting the visual symbolic language employed by the artist. The colours of the border are also significant in that they draw a parallel between the qualities of Mohammed Ali's character and those traditionally associated with members of the Sikh *Khalsa* - a 'brotherhood' established in 1699 under the tenth Sikh Guru, Gobind Singh, which was dedicated to fighting social and religious tyranny and injustice, and whose uniform of saffron and dark blue symbolises self sacrifice and strength of character.

Ali is often hailed as the greatest sporting legend of all time but what this portrait seeks to express more than anything is that his greatness goes far beyond the realms of sport. He has been described not just as 'one of the Gods of the ring' but also as 'warrior', 'preacher', and even 'prophet' (symbolised by the halo around his head). It is often said that the true measure of a man's greatness lies not in his physical strength but his inner strength of character, and as one writer puts it: 'The bottom line is that Muhammad Ali has always stood for what is right'.

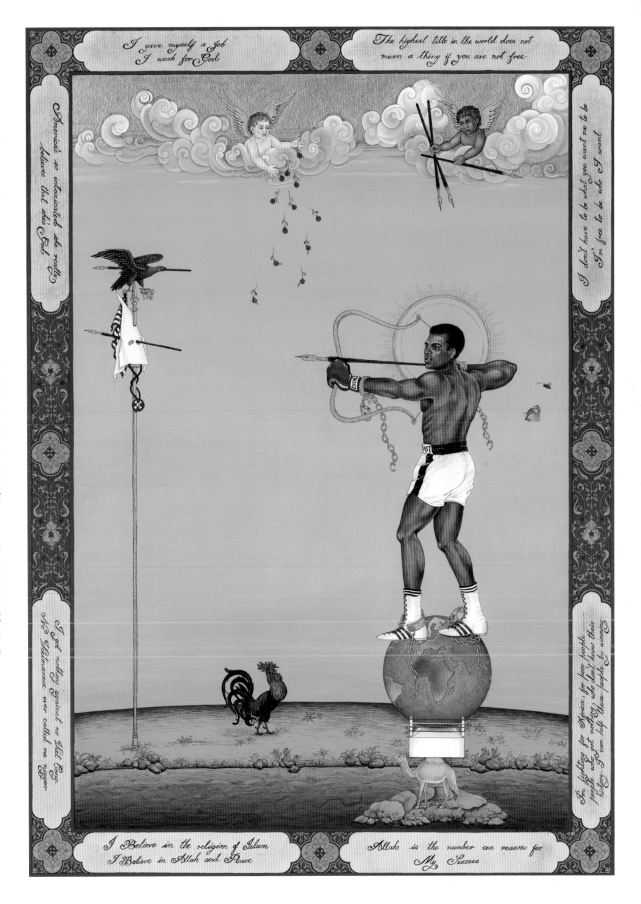

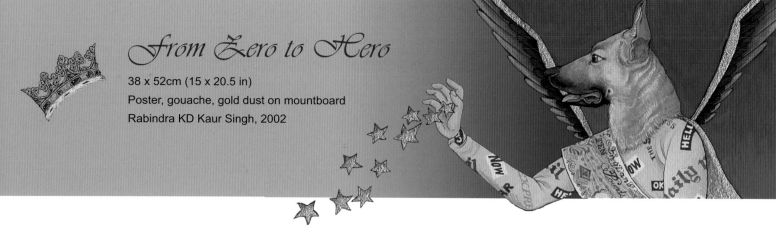

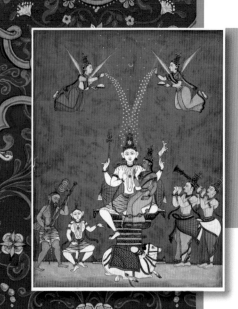

From Zero to Hero

38 x 52cm (15 x 20.5 in)
Poster, gouache, gold dust on mountboard
Rabindra KD Kaur Singh, 2002

This painting examines the relationship between the world of sport, media and celebrity. In particular it looks at the role that both the media and the commercialisation of sport have played in turning the humble sportsman into universal hero, celebrity superstar, and popular cultural icon. In a wider context it also comments on how, in a world obsessed with materialism and the cult of celebrity, secular icons have come to replace the traditional spiritual role models offered by world faiths. Epitomizing this theme, this symbolic portrait of David Beckham reflects an image of the footballer as portrayed through TV, newspapers, magazines and internet sites. The title of the painting itself is borrowed from an article about Beckham in *Hello* magazine and the quotes are taken from other media stories and interviews. Dubbed by the press as 'the new royal family', Beckham, Victoria - his pop star wife and celebrity in her own right - and son Brooklyn, are appropriately depicted crowned and enthroned. The throne, based on that featured in Victoria's official fan web site, also references the ones famously used at the couple's wedding. In addition, a royal insignia combining the letters D,V,R ('David and Victoria Reign') further emphasises the media's labelling of them as the 'king and queen of popular culture'.

A traditional 18th century Indian miniature (inset left) inspired the style and format, with its horizontal registers, flat perspective, stylized forms and hierarchical composition. It also draws on an established artistic convention adopted by many Indian artists in mythological and political imagery - that is, the use of multi arms to convey, within a single image, much more about the personality and stories behind the figures they depicted. In one hand 'King' Beckham holds a golden football as his orb, thus symbolising the realm over which he rules. Representing his status as fashion icon, he holds a pair of sunglasses in another hand, which allude to the 'Police' brand he endorses. In his remaining arms he holds his wife and son, symbolising how he is perceived by some as a contemporary exemplar for the devoted husband and model father. The nappies and everyday snacks (taken from the list of 'likes' on Victoria's official web page) present them as down to earth, ordinary people, as human as the rest of us, despite their elevated celebrity status. The bottle of mineral water (also listed on Victoria's website as Beckham's preferred drink to alcohol) highlights Beckham's 'decent' and 'well behaved', tee-total image, which has helped change the traditional perception and stereotype of footballers as beer drinking, macho men. Beckham has been described as 'the King of England', 'the great British Lion Heart', 'Mr. Britain' and 'the most famous Englishman in the world'. As captain of the England team and for his footballing skills, he is considered a 'national hero' who deserves a knighthood. As one newspaper editor put it: 'right now he epitomizes all that's great about being British'. As such, he wears the robes and crown of King Richard the Lion Heart (as inspired by a medieval painting of the same); his throne bears the emblem of the Tudor rose, and the great British lion supporting the English flag sits proudly at his feet. At the same time, an adoring fan presents a medieval knight's helmet on a golden tray in tribute to his idol. As a married couple, David and Victoria have brought together the worlds of sport and popular culture. So, whilst he wears his team strip, she holds a microphone, symbolising her own significant achievements and contribution to the music industry. On a different level, their union mirrors how in the 20/21st century, the increased commercialisation of sport has led to a blurring of the boundaries between these two once separate domains. It is a world where image is everything and where sporting events, driven by huge media sponsorship deals, have become more about advertising and selling than playing a game. Ultimately, media ratings have turned sport into big business, and sports people into celebrities that have become the perfect marketing tools. In Beckham's case, his selling power goes far beyond the multimillion

pound business of sports merchandising (represented by the figure, bottom, far left) and its traditionally male targeted audience. Hence, alongside the Adidas *Predator* boots he officially endorses, he wears a designer watch and jewellery. In addition, representatives from the fashion industry offer him other designer labels on golden trays, as eager to dress the sports superstar as they are the supermodel. One of the labels carries the Beckham name and this denotes how, because of his celebrity status, he has become a product himself, with his own trademarks (the famous Mohican haircut for example) being copied by his fans. The pile of newspapers and magazines that prop up the throne emphasise the role the media plays in creating and sustaining the world of celebrity. However, as the precarious manner in which these are stacked reveals, this media creation is built on shaky foundations. And, as the newspaper caption ('the worlds most hated man') reminds us, the media industry is as capable of cruelty as it is kindness because, either way, the story sells. In this respect, the image of the semi-human creatures clothed in bank notes shows the Beckhams 'adored' by the media as the 'perfect packageable product of [their] age', with a wide public appeal that traverses the worlds of sport, fashion, pop and celebrity. But the fickle nature of this 'adoration' is represented by the eggs and stars that are simultaneously showered on them by the media 'cat' and 'dog' in Tabloid heaven. The use of the cat and the dog to symbolise the double-edged sword of the media is significant as they can each be read both positively and negatively according to different cultural perspectives. So, the dog can represent man's best friend, faithful and loyal, or else, darkness and danger. Likewise, the cat has been taken to symbolise both good luck and fortune, as well as deceit, ridicule and cruelty. The cat and dog analogy also parallels the rivalry that exists within the media in their pursuit of the all-important 'exclusive'.

Overall, this is a positive portrait of the celebrity as a role model for success, achieved through hard work and determination. It also points to the vulnerability of those who find themselves in the spotlight because of that success, and questions whether their elevation to celebrity status through the media makes them fair game for ridicule at its hands. In addition, it asks how much we, as the viewing/reading public, can really know about the real people behind the media-created fantasy image. Ultimately, it supports the common sense dictate that one should not believe everything one hears in the media. For, whether depicted as zero or hero, the truth is that most celebrities, like us, are probably somewhere in between.

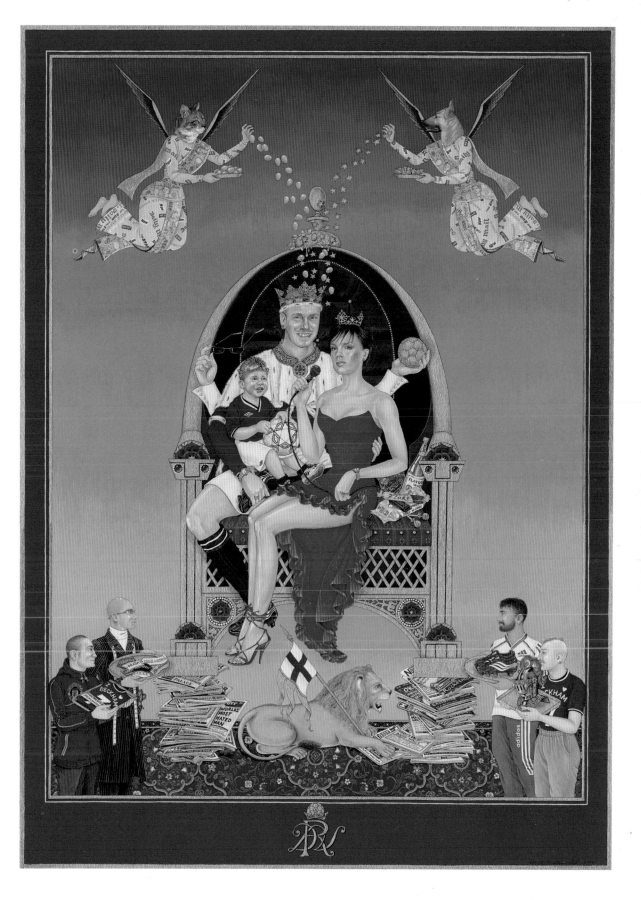

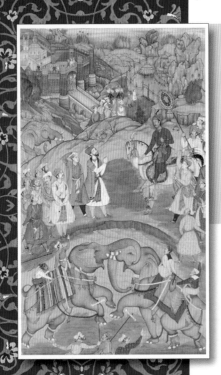

Battle of the Giants

47 x 31.5 cm (18.5 x 12.4in)

Poster, gouache, gold dust on paper

Amrit KD Kaur Singh, 2002

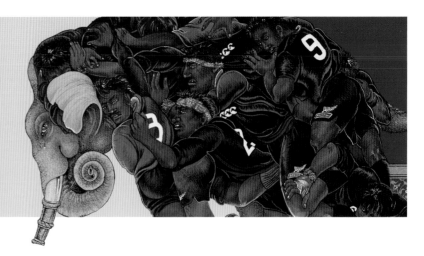

Inspired by Indian miniature paintings of the royal elephant fight (inset left), this image depicts the clash between opposing teams of American football and rugby. As two sports known for their muscle power and physically aggressive playing style, the impact of two elephants interlocked in battle provides an appropriate visual metaphor for this. The fact that the American football team seems to be losing ground to the *All Blacks* rugby team reflects the way in which the former, with all its body protective paraphernalia, has been derided as the less macho version of rugby, in the traditional rivalry that has existed between the two sports. On a parallel level of interpretation the scrum, in which both sides fight for possession of the ball, symbolises the battle of the media and consumer company giants vying for control of lucrative prime-time air space, and sponsorship of major sporting events. Against an escalating competitiveness, it seems that no part of the playing field is spared in the frenzy to maximise exposure from almost every conceivable camera angle. The juxtaposition of company logos and names, and their prominence within the composition, creates a visual confusion that mirrors the 'in your face' tactics that has turned the sports pitch into a sales pitch - with brand imagery being digitally created on screen and strategically placed on pitch for optimum effect. The resulting ambiguity leaves the viewer wondering whether the central focus of the painting depicts an actual game in progress, or an advertising billboard on which the game has merely been illustrated against a backdrop of some of its sponsors.

On another level of interpretation the elephants present a visual analogy for the economic, political and cultural divide that has historically existed between east and west, which in the context of this painting, is taken to be synonymous with the relationship between traditional cultures and western society, symbolised by the black and white elephant respectively. Alluding to its colonial origins, the choice of the New Zealand *All Blacks* to represent the black elephant is particularly significant in this respect. As the first 'native' team to '[hand] out thrashings … to any Home Unions', they contributed to sporting history by striking a symbolic blow on behalf of all colonies to the might of the British Empire, thereby challenging traditional imperialistic notions of white superiority. Extending this to a more contemporary context, the *All Blacks* have come to symbolise the growing defiance to what some regard as the continuation of Empire through the multinationals - whose monopoly of global resources in a world market ultimately serve the economic, political and cultural interests of Western superpowers. As a team famed for its on-pitch performance of the *Haka*, a dance that expresses the passion, vigour and identity of the Maori race, the *All Blacks* acquire additional significance in representing the reassertion of traditional cultural identities against the westernising tendencies of globalisation. Like *The Killing Game*, this work draws on the composite convention within Indian traditional art, which opens it up to multiple levels of interpretation.

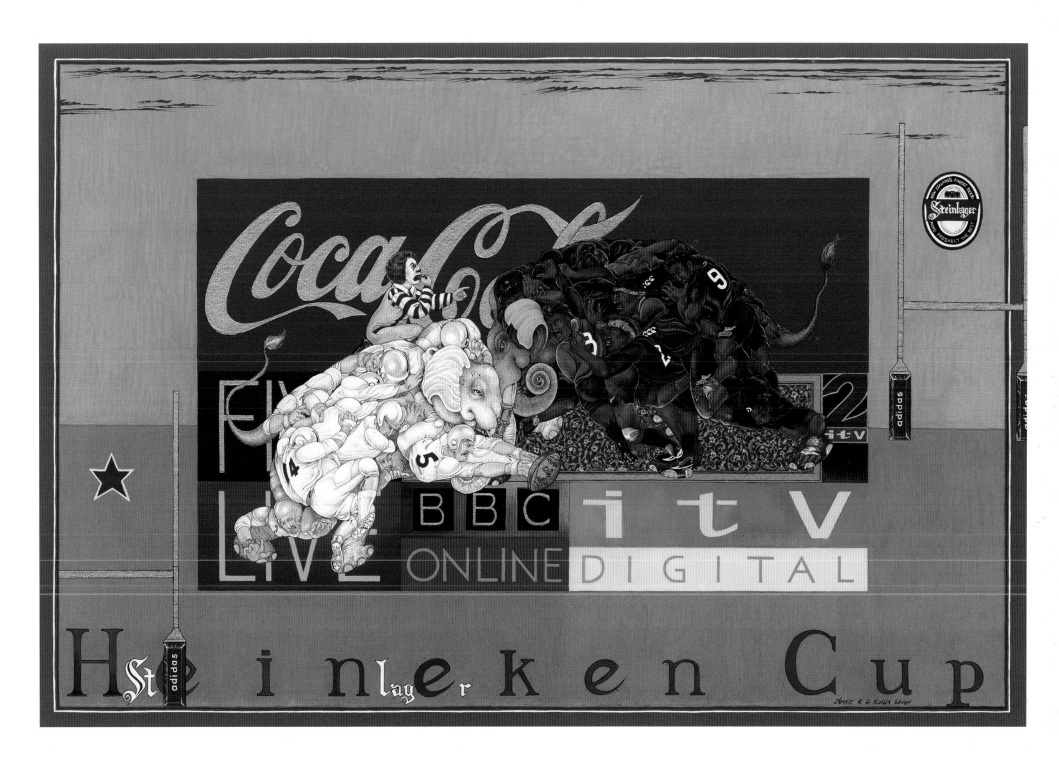

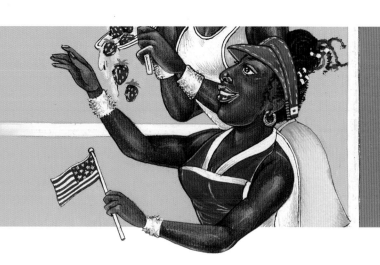

Dressed to Kill

23 x 38 cm (9 x 15in)
Poster, gouache, gold dust on mountboard
Amrit KD Kaur Singh, 2002

Here, Venus Williams's accomplishment within tennis is presented as an extension of the wider impact of Black women on 20/21st century popular culture across the fields of sports, cinema, music and fashion. This is an image about ultimate 'girl power', demonstrated by those women who have challenged traditional social stereotypes of black underachievement, and pushed the boundaries of success within the global entertainment, fashion and beauty industries, known historically for their white-bias tendencies. Dwarfing the other figures in the composition, Venus's imposing presence mirrors the stature she shares with her equally famous sister, Serena. Together the sisters have rocked the conservative white image of tennis to become the first Black women to win the finals at both Wimbledon and the prestigious US Open final. The painting is also about how the sports arena in general has become a showcase for designer sportswear companies. Monopolising the free advertising from spin-off media coverage of the game, they play on the growing tabloid tendency to pander to a mass readership more interested, it seems, in what the sports personality is wearing, than how they are performing. In this respect, Venus is shown wearing the outfit which spurred the press headline 'Venus eye trap'. In a context where celebrity status is a major selling point to potential sponsors, this further points to the growing pressure on sports personalities to develop a public image that gives them an edge over the competition by grabbing those all important headlines. The suggestion here is that in Venus's case her risqué approach to fashion on the court is an extension of a self-created personal style whose media appeal has acted as a catalyst for her equal success off the court - a style that reinforces her highly sellable image as a young, active, vibrant, young woman who has totally broken the mould in terms of the traditionally reserved image and strict dress code of tennis. It is a painting which also shows Venus as a truly modern icon who reflects how far social attitudes to fashion and women have come since the early days of women's tennis, where Victorian values of decency and modesty dictated ankle length skirts and chin high necks for work and leisure. Proving to be one of the most celebrated female sports personalities of her time, Venus takes her place at centre stage both on the tennis court and the catwalk whilst adoring African-American female fans gaze on, wearing replicas of her outfits.

Symbolising her universal renown within the field of tennis, she serves the ball towards a distant pond in the form of a global map. But as other elements in the painting indicate, the true measure of her success is revealed by the fact that she has acquired a level of fame which transcends not only her own sport, but all sport. It is the kind of fame that is immortalised in an episode of *The Simpsons*, influences primetime national network broadcasts, commands multimillion dollar sponsorship deals and has stars for fans. Amongst these are female celebrities like Whoopie Goldberg (who reportedly walked on to a set during the filming of *Hollywood Squares* in 2002 and started bowing towards Venus and Serena) and the pop legend Dionne Warwick (who serenaded Venus with a round of *That's What Friends are For* at Wimbledon the same year). Even the Black queen of the catwalk herself, supermodel Naomi Campbell, is seen stepping aside for the sports star turned model who has her own collection of designer wear. The composition follows that of an Indian miniature which depicts a group of tribeswomen getting ready for the hunt (inset left), which is unsual in that it represents a female slant on a traditionally male dominated theme. Similarly, this portrait highlights the female perspective within what is popularly perceived as the male world of sport.

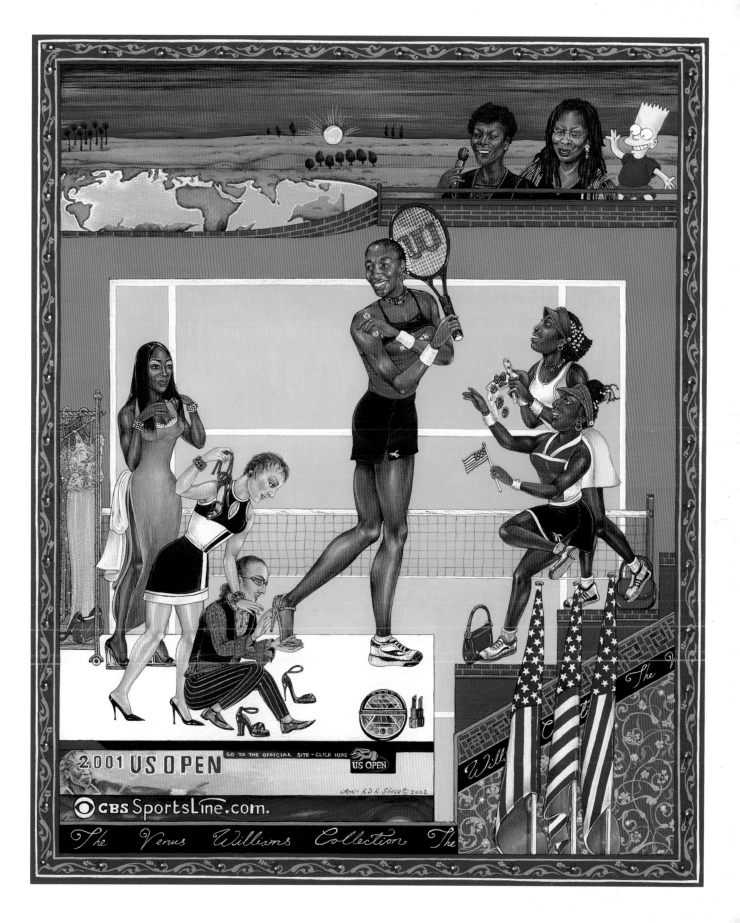

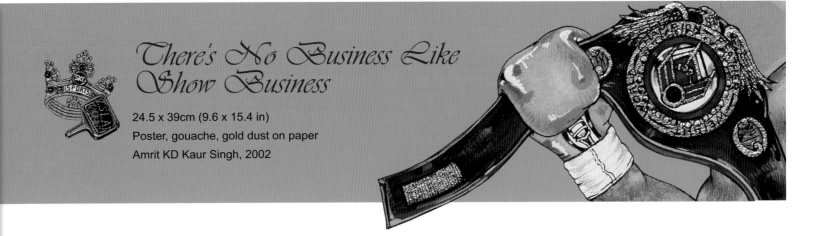

There's No Business Like Show Business

24.5 x 39cm (9.6 x 15.4 in)
Poster, gouache, gold dust on paper
Amrit KD Kaur Singh, 2002

This work contrasts the simplistic way in which a sporting hero from the Imperial Mughal Court was represented through art, with how the sporting hero of today is projected through the media with all the ritz, glitz and trappings of show business.

As the first in a set of two paintings within the *Sportlight* series which look at the entertainment value of boxing, it shows Prince Naseem Hamed - renowned for his flamboyant image, entertaining fighting style and spectacular ring entrances - as the king of showmanship. Appropriately, it sets the scene of his highly publicised fight against Barrera at the world capital of entertainment itself, Las Vegas. Most of the details in the image are factual, from the boxing ring sponsor logos, neon signage and spotlights to the Islamic banners and circular frame hoist behind Naseem's head, all of which appeared in the Channel 4 documentary whose title is written across the ring floor. Even the throne is an actual copy of one of his more outrageous stage props, whist the crown, complete with Sky logo, replicates the one presented to him by Frank Bruno during one of his many publicity stunts.

Drawing on Naseem's published biography *Prince of the Ring*, other specific details also reflect the boxer's personal views about the development of his career, and responsibility as a well-known sports figure. For example, the visual references to his Muslim background denote the significance he attributes to his faith for motivating him to excel in his sport, as well as the reason for his success. In this respect, the Islamic banners recall the public declaration of faith that Naseem makes at the start of each fight. Linked to this is the importance he places on presenting a 'clean image' of sport, and creating a positive role model for his religion. At the same time the painting points to the multicultural nature of Naseem's identity. As a Yorkshire-born Muslim representing Britain in international competitions, Naseem acknowledges his status as a universal role model transcending cultural boundaries. Obvious symbols of identity here are the Union Jack and white Yorkshire roses that decorate the throne cushions.

With a proud record of almost unbroken prestigious titles under his belt, Naseem's public image projects an air of self-confidence which some might argue borders on arrogance. But whether he is delighting his fans or irritating his critics, the 'Naseem showman style' is simply captivating to watch both in and out of the ring, proving that good sports viewing is as much about playing the audience and media as it is about playing the game. The odd-coloured gloves and mirror relate to two such plays to camera in a Channel 4 documentary, when Naseem kept viewers in suspense about which gloves he would finally choose for the big fight, and entertained them with his amusing image obsessed, hair style scene. In keeping with Naseem's depiction as the archetypal master of performance, he is shown under the spotlights astride a boxing ring illuminated by Hollywood-style stage lights. His regal status as the reigning monarch of boxing showbiz is further affirmed by the specific choice of the Yorkshire rose (an emblem of the royal house of Stewarts) and the particular shade of blue adopted for the background - typical of the royal portraits of the Imperial Mughal school of miniature painting.

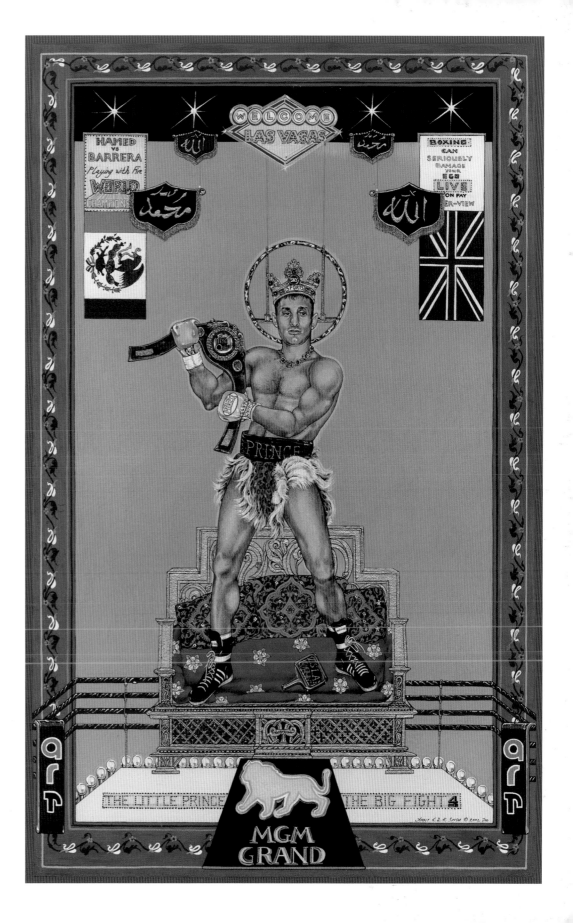

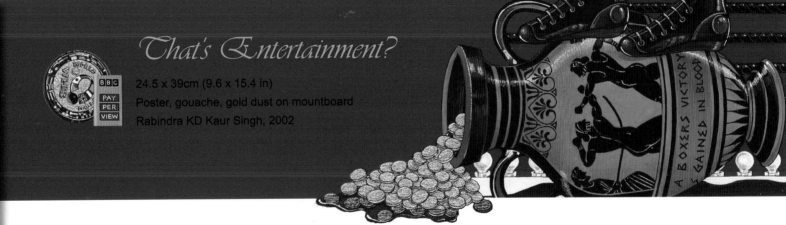

That's Entertainment?

24.5 x 39cm (9.6 x 15.4 in)
Poster, gouache, gold dust on mountboard
Rabindra KD Kaur Singh, 2002

Like the image of Prince Naseem, this portrait of Mike Tyson has been inspired by one of a series of official portraits of renowned sportsmen of the Court of the Mughal Emperor, Jahangir, housed at the Victoria and Albert Museum. However, in complete contrast to the light hearted look at boxing as an entertainment business offered by There's *No Business Like Show Business*, this painting deals with issues surrounding the sport's uglier side. The latter, it may be argued, is embodied by the infamous boxer Mike Tyson, variously described by writers as 'beast', 'evil', 'ruthless' and 'the most demonised man in sport'. In this portrait the boxer is shown handcuffed and with a human ear hung around his neck. Making reference to his conviction and imprisonment for rape and the fight in which he bit off part of his opponent's ear, these details serve to symbolise his bad boy image both outside and inside the ring. There are many who believe that Tyson should never be allowed to box again, not because his misdemeanours make him an unsuitable role model, but because they have brought shame on the sport and seriously damaged its 'respectable' image. This would be a valid argument, if only boxing was truly the 'noble art' that its apologists would have us believe. However, this painting argues that it is not and never has been. For example, when boxing's first rules were introduced by Jack Boughton in 1743, they were done so not in an attempt to civilise the sport as is commonly argued, nor to protect the physical safety of the fighters, but because:

> 'The sport would have continued to be dogged by unsatisfactory conclusions and was therefore in danger of losing its gamblers. The rules helped persuade gentlemen gamblers, wealthy merchants and royal patrons to continue their support of pugilism'.

In this respect Tyson's public image merely reflects the sport's true colours, as the ancient Greek vase on which he stands represents. Decorated with a scene of two boxers of the day and their motto: 'a boxer's victory is gained in blood', we are reminded of the historical origins of boxing as a brutal and violent blood sport. Blood and gold coins pour from the vase onto a boxing ring which, surrounded by footlights, has been turned into a stage. This represents both the multimillion pound entertainment business that this 'brutally dangerous and potentially fatal game' has become, as well as those who because of their vested interest, are happy to promote, glorify, and thereby create demand for this form of 'entertainment'. Major players in this context are the main TV channels whose logos are seen on the green towels hanging over the ropes. As one journalist from the *Daily Mail* put it:

> 'You will always find an audience for violence as a spectator sport if you promote it well … Without publicity boxing would wither and die … would disappear. How much demand for cock-fighting goes on today?'

Many believe that boxing should be banned. They believe that beneath the guise of respectability provided by promoters boxing is fundamentally no better than the barbaric bear-baits and cock-fights it once shared billing with, or than other blood sports that continue to be practised today. This opinion is symbolised by the image of a fox being chased by a hound across the top of the painting, and the blood red colour that dominates the palette. This

painting, therefore, questions the ethics of a so-called civilised society which at best tolerates and at worst encourages violence in the name of entertainment. Above the hunting scene a quote from the Roman orator, Cicero, serves as a reminder that this is a question that goes back as far as the gladiatorial origins of blood sports itself. At the same time, there is an element of sadness to the portrait, which reflects a degree of sympathy for a boxer who could be perceived as a victim of circumstance, and a man ultimately failed by an industry that has encouraged and exploited the 'bad boy' reputation as a valuable marketing image.

Steve Bunce in his book, Boxing Greats reinforces this view when he says:

> 'D'Amoto [Tyson's trainer] concentrated on curbing Tyson's emotions in the ring but ignored his dangerous behaviour outside it. The product became too important and indiscretions were overlooked and excused. Unfortunately, Tyson's boxing education failed to include valuable lessons in distinguishing between right and wrong'.

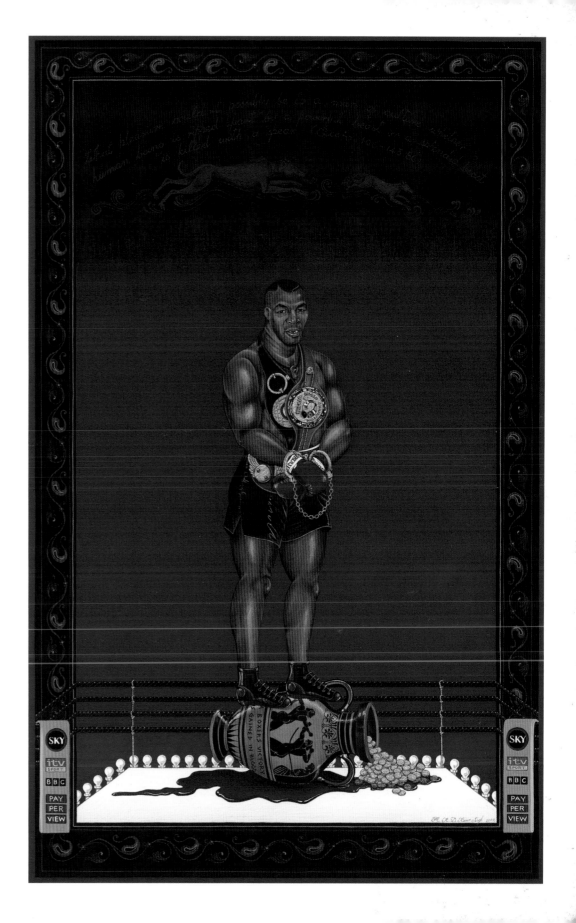

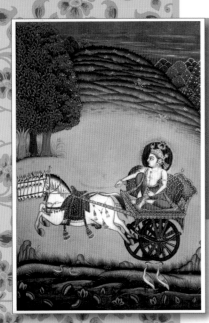

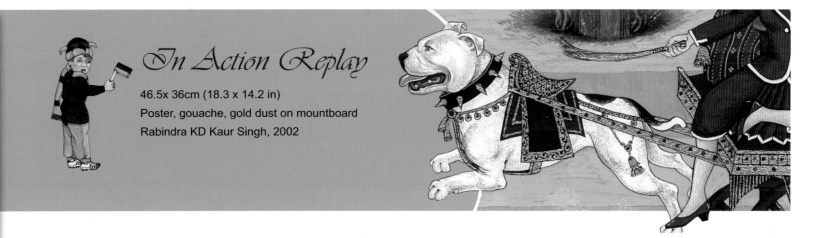

In Action Replay

46.5x 36cm (18.3 x 14.2 in)
Poster, gouache, gold dust on mountboard
Rabindra KD Kaur Singh, 2002

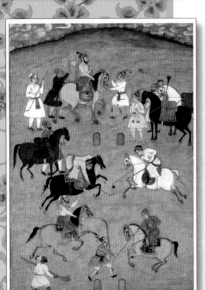

This satirical painting takes a look at the media hype that invariably surrounds football matches between England and Germany, or Argentina. In particular it focuses on how there is a tendency for the media to exploit the historical rivalry between these countries, thus turning supposedly friendly games - most notably the European and World Cup - into metaphors of war. For example, in the 1994 European football championships some newspapers talked about a football war between England and Germany, which many thought was going too far. More recently, old gripes with Argentina over issues both on and off the pitch (namely, Maradona's 'hand of God' in the 1986 World Cup, and the Falkland war) were stirred up again when England captain, David Beckham, broke his foot as a result of a foul committed by an Argentinean player on the opposing Italian team. The latter became a 'villain' and 'evil Argie', all for the sake of selling more newspapers and increasing interest in a forthcoming, crucial match between England and Argentina. Accordingly, this painting depicts an action re-play of World War II and the Falklands war being played out on the football pitch. In the centre of the 'battlefield' political leaders Winston Churchill and Margaret Thatcher, along with their respective adversaries, Adolf Hitler and General Galtieri, charge towards each other in war chariots modelled on those found in traditional Indian miniatures (inset top, left). Amidst the explosions and exchange of fire overhead, the football game itself is nowhere to be seen, completely lost in all the media hype. With 'football [being] the dominant sport for sponsorship in the UK and globally' it is easy to see why the media is keen to create a drama which will heighten tension and excitement around the game. However, whilst some may see this particular kind of good guys versus bad guys presentation as harmless fun, the painting questions this. For, surely, in keeping with the spirit of the game and sportsmanship, matches should be reported on with impartiality and the skills of individuals or teams celebrated equally, regardless of their race (as represented by the football referee who stands in the midst of all the chaos). Blowing on his whistle to stop 'play', the referee holds up a red card in protest of the activities taking place on the pitch. The painting questions to what extent media reporting encourages the unruly and racist behaviour that often accompanies major football events. Hence, in the bottom half of the pitch a battle of another kind takes place as English football hooligans clash with German and Argentine fans. Certain stylistic and compositional elements have been inspired by different schools of miniature painting. So, whilst the decorative clouds, the bird's-eye view of the pitch and the horizontal placement of the figures are borrowed from the conventional depiction of a polo match (inset bottom, left), many of the brawling fans strike poses which are typical of traditional wrestling scenes. The explosions and missiles that fly overhead are copied from battle scenes of the famous Padshahnama manuscript, which records the reign of the 17th century, Mughal emperor, Shah Jahan. Meanwhile, the cropping of figures and their placement outside the main frame of action is another common characteristic of the Mughal style of painting, as is the symbolic use of animal forms (i.e. the British bulldog and Argentinean palomino). Sport is a universal language which, if used positively, has great potential for uniting cultures and people from all over the world. In this respect, this painting criticises those within the media who choose instead to use it to reinforce negative, racial stereotypes and attitudes in order to sell their papers and boost TV ratings. The painting serves as an example of how media presentation has the power to affect people's views about not only sport but also wider social and political issues. It also serves as a reminder that there is a difference between expressing national pride and racism.

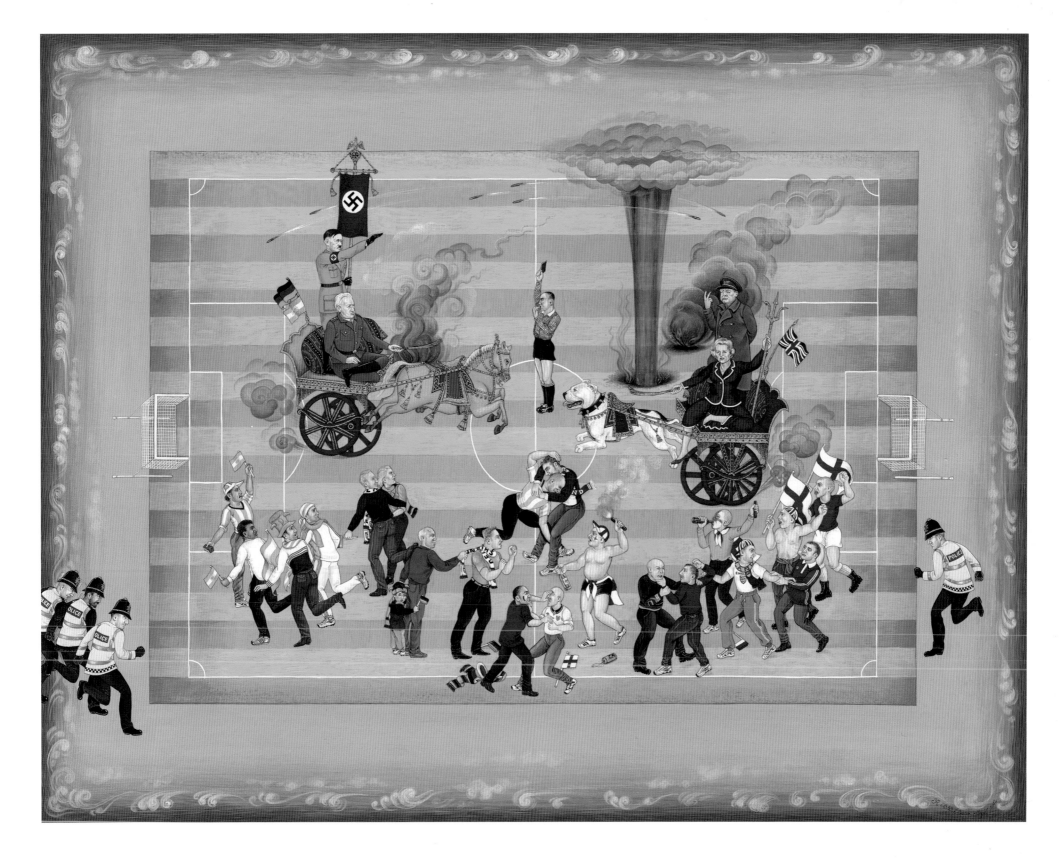

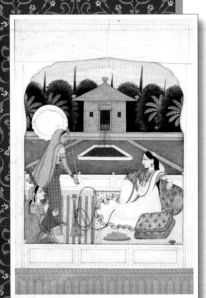

The Beautiful Game

27x 40cm (10.6 x 15.75 in)

Poster, gouache, gold dust on mountboard

Amrit KD Kaur Singh, 2002

As a visual pun on the popular reference to football as 'the beautiful game', this painting comments on how the traditional macho image of the sport has been somewhat feminised by the involvement of some of its star players in a beautiful game of another kind - the endorsement of cosmetic and personal hygiene products whose use has conventionally been regarded as the prerogative of female consumers. It focuses on David Ginola, one of football's most notorious exponents of the cosmetic and fashion industry, known as much for his full head of impeccably styled, glossy hair and designer suits as for his skills on the football pitch. Rubbing shoulders with supermodels and film stars, he has turned the rugged image of football on its head to become one of the world's most glamorous male sporting figures. His working schedule includes star billing on chat shows, international film festivals, press calls, book signings and photo shoots for TV commercials, glossy magazines and billboards. Whilst Ginola's good looks and well groomed image on and off the pitch have made him the butt of jokes amongst a male oriented paparazzi and fan base, they have 'gained the attention of many adoring female fans'. In fact, some have argued that he has probably done more to bring women into the fold of football (thereby challenging the traditional male face of the game) than all the propaganda and PR efforts of the FCM marketing machinery put together.

Outside the football world, his image reinforces modern society's preoccupation with the body beautiful but in particular, the growing male obsession with self-image. In this respect, the central theme of this work also highlights how the sports personality has become an important icon both for influencing established attitudes and perceptions and for reflecting general trends in shifting patterns of social behaviour. The reference to Ginola's support of the Red Cross's anti-landmines campaign adds another dimension to the sporting hero's relevance in society, as a figurehead for effecting political change. It is a comment on the power of celebrity as a privileged status that can be used as a force for good in the world.

Like other images in the *Sportlight* series, this painting highlights the impact that media and sponsorship have had on sport in the 20/21st century. The prominence of Internet and web-related company logos alludes to the relatively modern advancements in communication technology that have taken the phenomenon of sports sponsorship to new levels. Sports figures now have access to a diverse range of promotional and economic opportunities that far outstrip the potential of conventional TV, radio and printed media, and allow them to be more self-defined, direct and immediate. In a context where the official fan website has become a standard feature of celebrity status, the painting mimics the layout of a web page. Complete with access buttons, online shopping and cyber ads, an ever-widening fan base is provided with a constant lifeline to their idol, while the money-spinning celebrity/sponsor relationship continues to tick.

On another level, the painting shows how the sports personality is as much a commodity as the products they sell. So the Aston Villa stadium backdrop and Ginola's mismatched kit represent his transfer to various clubs including Aston, Tottenham Hotspurs and Newcastle. His subsequent transfer to Everton and original attachment to French teams is hinted at in the border details. The French/English connection in itself, and the conspicuous placing of a Birmingham mosque within the landscape, symbolise how sport as a popular interest, transcends all cultures.

Finally, the painting comments on how commercialisation has eroded notions of national loyalty and identity in sport, encouraging the emergence of multi-nation football teams whose individuals play for whoever pays the most rather than for 'king and country'. This in turn highlights issues relating to what many would consider the unfair advantage of wealthier countries over poorer nations who struggle to compete in a global sports business where success can be bought by those who can afford the best players.

Stylistically the composition draws on conventional representations of ideal female beauty in Indian miniatures. Typically, these might show a woman at a balcony (framed by an arch) holding a mirror or comb, or else relaxing in a palatial garden whose surroundings poetically echo the perfection and delicacy of her beauty (insets left).

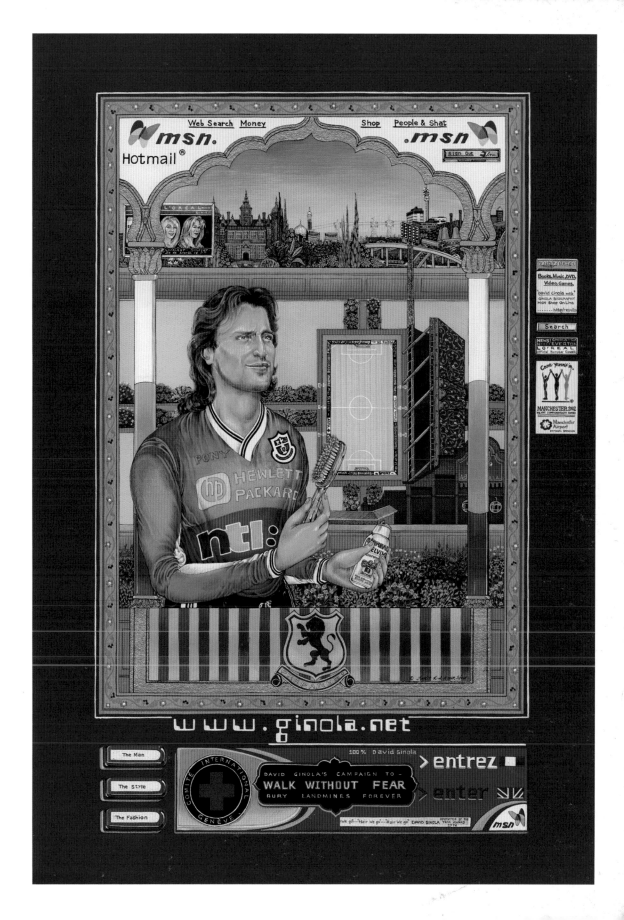

Dance on Ice

36.5 x 50.2cm (14.4 x 19.75in)

Poster, gouache, gold dust on mountboard

Rabindra KD Kaur Singh, 2002

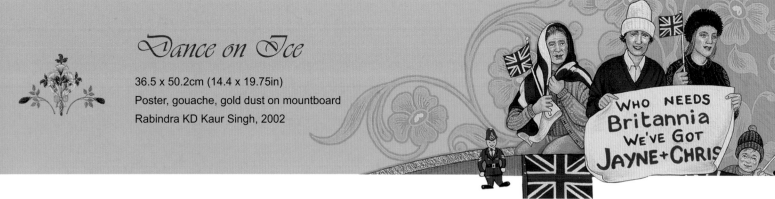

nspired by a particular 18th century example in the Victoria and Albert Museum collection this light-hearted portrait of world figure skating champions, Torvil and Dean, translates a conventional format used to depict a pair of girls performing *Kathak* dance - a popular subject in the Indian miniature painting tradition (inset left). Recording a defining moment in their careers, not to mention British sporting history, Torvil and Dean are seen performing their famous '*Bolero*' dance routine which won them gold medals at the 1984 Sarajevo Winter Olympics. Captured in mid twirl with their hands clasped, their dynamic pose mirrors exactly that of the *Kathak* dancers. The oval-shaped ice rink and the bouquets thrown onto it, similarly echo the compositional features of the original miniature. The complexity of their dance on ice, its aesthetic beauty and the perfection of their performance (for which they scored perfect sixes), is symbolised by the symmetrical, interlacing arabesque 'engraved' in the ice by the blades of their skating boots. In one corner a group of Torvil and Dean supporters wave their Union Jacks and display a banner in honour of their heroes, whose personal success in the ice rink turned them into symbols of British achievement in sport. In a wider context this portrait comments on how, as the words on the banner indicate, world sporting events such as the Olympics and Commonwealth Games play an important role in providing a vehicle for the expression of national pride and identity.

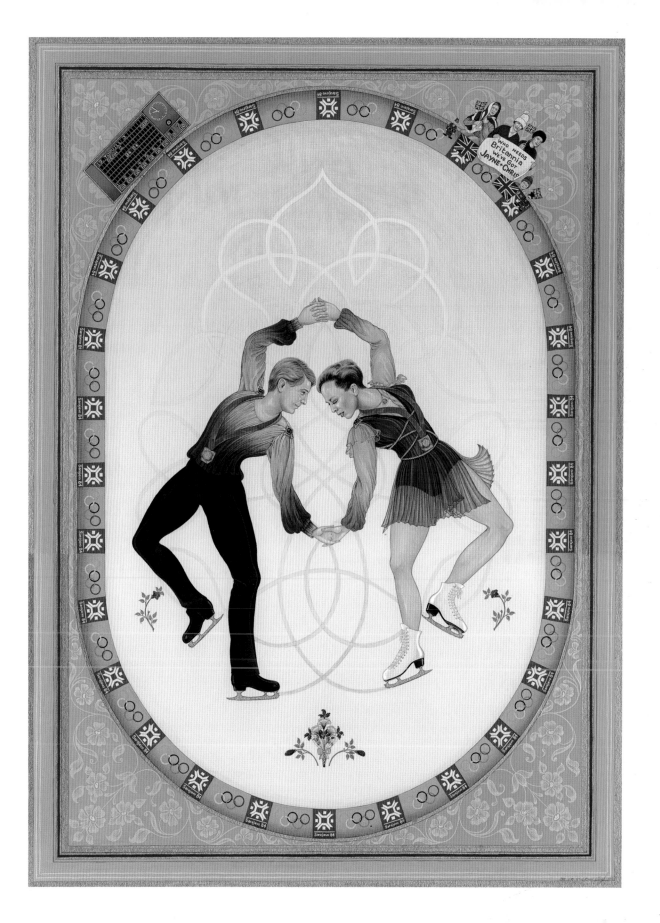

List of plates

Paintings by The Singh Twins

Introduction Illustrations

	Page
Reagan and Thatcher,1987	4
Nineteen Eighty-Four,1998 (detail)	4
Diana:The Improved Version,1997/8	5
All Hands on Deck,1997	6
Nyrmla's Wedding II,1985/6	7
Manhattan Mall, 1997	8
O Come All Ye Re-eds,1996	9
Daddy in the Sitting Room I-III,1987	11

Iqbalnama Series

The Laird of Lahore	18
Marriage to a Swiss Bride	20
To the Manor Sporran	21
All for Burns and Burns for All	22
Laird Singh's his Tartan's Praises	23
Lesmahagow Durbar	24

The Hart and Blake Project

Love Lost	28
The Grim Reaper	29
The Beast of Revelation	30
Paradise Lost	31

Facets of Femininity Series

Princess Diana	34
Mother Teresa	35
Eva Peron	36
Margaret Thatcher	37
Marilyn Monroe	38
Maria Callas	39
Madonna	40
Geri Halliwell	41

The Art of Loving Series

Some Like it Hot (Burning Desire)	45
Raining in My Heart (Longing)	47
Star on a TV Show (Public Relations)	49
I Feel Pretty (God's Gift)	50
Funky Weekend (Absent Lover)	51
To All the Girls I've Loved Before(Playboy)	53
Solitude (Absent Lover)	55
Stepping Out with my Baby (My Donna)	57

Sportlight Series

The Killing Game	61
The Greatest	63
From Zero to Hero	65
Battle of the Giants	67
Dressed to Kill	69
There's no Business Like Show Business	71
That's Entertainment?	73
In Action Replay	75
The Beautiful Game	77
Dance on Ice	79

t (top)
b (bottom)

Paintings from Public and Private Collections

Insets and details

	Page
Illustration from the *Janam Sakhi* of Guru Nanak,19th century.	19
Officer of the East India Company, Company School. By Dip Chand, c1760-63.	21
Portrait of Emperor Aurangzeb, Mughal, c1830.	23
Akbar Shah II in the *diobar-i-Khess* in the Imperial Palace, Delhi Late Mughal,c1830.	25
Illustration from a book of poetry, Persian, Hart Manuscript c1590.	28t
Illustration from a book of poetry. Persian, Hart Manuscript dated c1731	28b
The Grim Reaper, Italian, c1470-80.	29
The Blue Bower, Dante Gabrielle Rossetti, 1865.	33-41
Awaiting the Lover, Indian (Gharwal) Punjab Hills, c1780-1800.	44
Usha Looking at Portraits, Kangra, Early 19th century.	46t
The Brooding Lady, Punjab Hills, ca 1820-25.	46b
Radha and Krishna in Forest. Kangra, Punjab Hills. 1810-12.	48t
Lovers on a Bed, Indian (Garhwal), c1780-90.	48b
Jahangir (detail from Jahangir and Jesus). Minto Album. Hashim, c 1620 and Abu 'l-Hasan, c1610-20.	50
Unknown, Mandi, Punjab Hills, ca 1840.	51
Illustration to *Raga Hindola* (The Swing), Murshidabad, c1740-1760.	52
Girl Preparing a Courtyard for Her Lover, illustration to the musical mode *Gunakali Ragini*, Indian (Bundi), c1640.	54t
The Expectant Heroine,(Mandhi) Himachal Pradesh State,1810-25.	54b
Lady at her Toilet, Indian (Mankot, Pahari), c1730.	56t
Lady at her Toilet with Maids (*Ramkali ragini*), Rajashan, Mid 19th century.	56b
Rao Umed Singh of Bundi Killing Wild Boar, Bundi, c1760.	60t
A Mythical Creature Riding a Composite Bull, Murshidabad, c1750	60b
Jahangir Symbolically Killing Malik 'Ambar, Minto Album. Abu'l Hasan c1615-20.	62
Siva and Paravati Enthroned on the Bull, Eastern Deccan, c1780.	64
Akbar Watching and Elephant Fight at Nagaur. From the *Akbarnama*,c1590-98.	66
Tribal Women on a Hunting Expedition, Eastern Deccan c1780.	68
Archer Stretching Steel Bow. Large Clive Album, Mughal, First half 18th century.	70
Jahangir's Court Wrestler, Mughal, c1516.	72
Surya in his Chariot, Bundi, c1770.	74t
Polo. The Large Clive Album, Mughal, c17th century.	74b
Portrait of a Lady, Jaipur, c1790.	76t
Princess Listening to Music on Terrace, Guler, 1810-20.	76b
Two Kathak Dancers, page from Album, Mughal, Early 18th century.	78